MISSOULA

MONTANA'S FIVE VALLEYS

IMPRESSIONS

FARCOUNTRY
PRESS

PHOTOGRAPHY BY NELSON KENTER

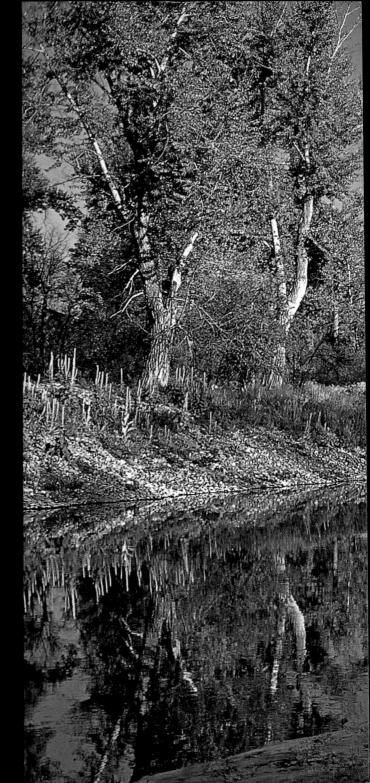

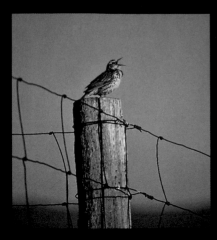

Above: Montana's state bird, the western meadowlark, often perches on fence posts, guarding its territory and singing in its distinctive warbling whistle that goes down in scale.

Right: The Clark Fork River flows north and west through Montana, bisecting Missoula on its 300+-mile course from its headwaters in the Silver Bow Mountains of Montana to Lake Pend Oreille, Idaho.

Title Page: Missoula's extensive trail system, built here atop the old Chicago, Milwaukee & St. Paul railroad bed, passes by the historic Milwaukee Depot in the heart of the downtown riverfront.

Cover: The Missoula valley extends west from an overlook on Mount Sentinel. Missoulians delight in leading guests up the steep switchbacks of the "M" Trail to take in the view.

Back cover: Like a shining beacon powered by sunlight, 4,764-foot Mount Jumbo rises above the university, providing a beautiful backdrop to the city.

ISBN 10: 1-56037-442-X
ISBN 13: 978-1-56037-442-8

For more information about our books, write Farcountry Press, P.O. Box 5630, Helena, MT 59604; call (800) 821-3874; or visit www.farcountrypress.com.

Created, produced, and designed in the United States.
Printed in China.

13 12 11 10 09 08 1 2 3 4 5 6

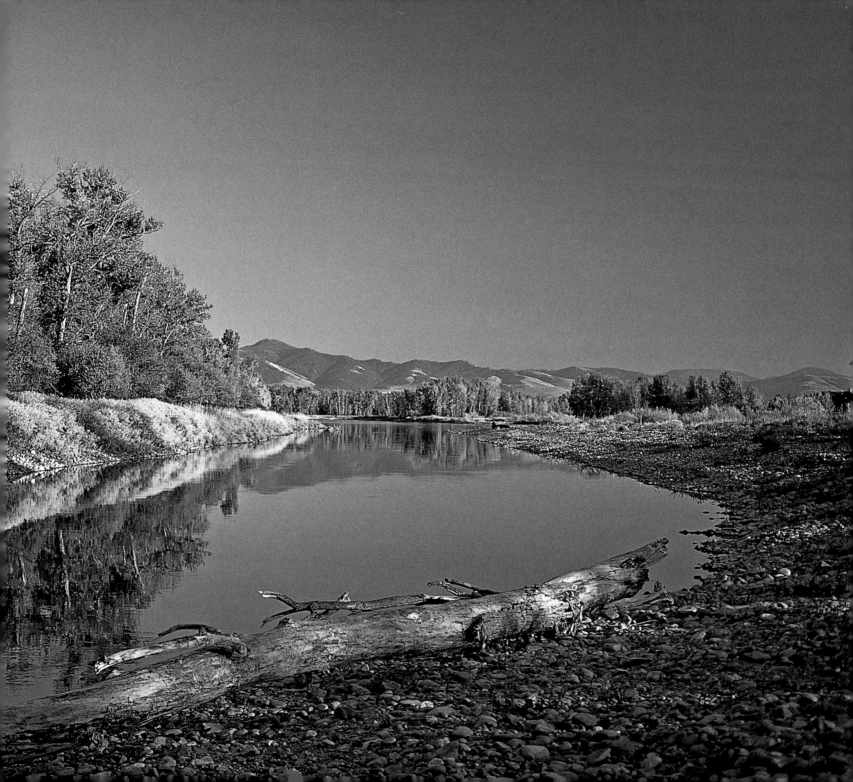

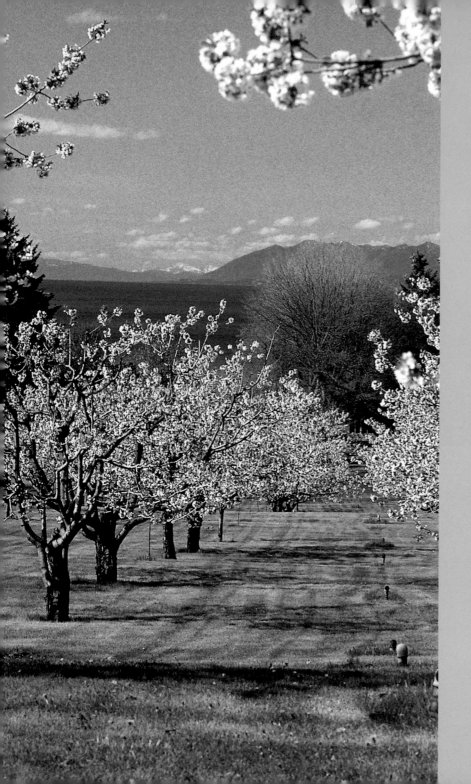

MISSOULA
impressions

by Daniel Kemmis

Missoula is a small city by most standards, but still it is the largest city in the Rockies that is entirely surrounded by mountains. In some subtle way, that fact seems to have played a role in giving Missoula the unique personality that so many people love about the town.

The mountains—always in sight no matter which way you look—invite your gaze, and often seem also to invite your thoughts and dreams, upward and outward. Missoulians live, hour to hour, with the awareness that wild country (not to mention wild animals) wait within easy reach in any direction. So, over the years, Missoula has become home to people who love open country, whether for fishing, hunting, hiking, or just soaking up solitude.

But if being surrounded by wild country and resting at the "hub of five valleys" has always been a major part of what defines Missoula, there's something else that is maybe even more important. Home to the University of Montana, Missoula attracts not only fine scholars and students, but steadily growing numbers of people with an appreciation for the finer things in life, whether it's good music, literature, art, or well-prepared food.

Missoula draws an unusual blend of outdoor enthusiasts, many of whom also bring with them a deep appreciation for the good life. In other parts of the country, you might get your outdoor fix by driving to the mountains, and then feed your cultural appetite by traveling to a nearby city. But because there are no big cities within hundreds of miles, Missoulians discovered that if they were to have ready access to the best of what cities offer, they would have to create it themselves. And so they have. From Missoula Children's Theatre to a world-class set of creative and nonfiction writers, from the International Choral Festival to the International Wildlife Film Festival, from the finest farmers' market in the region to the String Orchestra

of the Rockies, Missoulians seem never to exhaust their capacity to provide one another and anyone else who happens to stop by with an amazingly rich menu of engaging activities.

And at this point I have to put on my ex-mayor hat and point out another dimension of Missoula's personality that lies hidden behind this wealth of cultural and social opportunities. The people who have created all these features of the good life have, in the process, created something even more rare and valuable; they have created and sustained a democratic culture more vibrant than any but a handful of communities can claim. People had to learn to work together to create the first hand-carved carousel built in America in decades, or to build a world-class kayak wave in the middle of town, and they couldn't get all that work done unless they continually recruited new people to help. So it turns out that Missoula is not only a great place to be if you love both the outdoors and the best of city life, but it is also a great place for people who want to be involved in making the community even better than it was before.

There's no end to that story, of course. And there's no end to the enthusiasm of this former mayor who loves his hometown, loves having his children return to the city they were all raised in, loves, finally, having a chance to take his first grandchild for a ride on that carousel. Like thousands of others, Missoula is part of who we are, and also like thousands of others, we have had a chance to be part of what Missoula has become: a sweet little city in the mountains.

Daniel Kemmis is a Senior Fellow at the University of Montana's Center for the Rocky Mountain West. A former Mayor of Missoula and former Speaker of the Montana House of Representatives, he is the author of *Community and the Politics of Place* and *The Good City and the Good Life*.

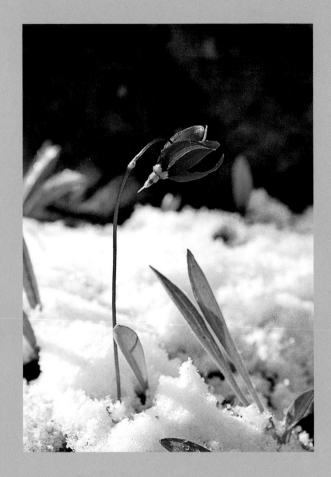

Above: There are about ten species of shooting stars in the West. These distinctive plants are always among the first species to brave the unpredictable weather of springtime.

Facing page: Private orchards along Flathead Lake produce some of the region's most coveted cherries.

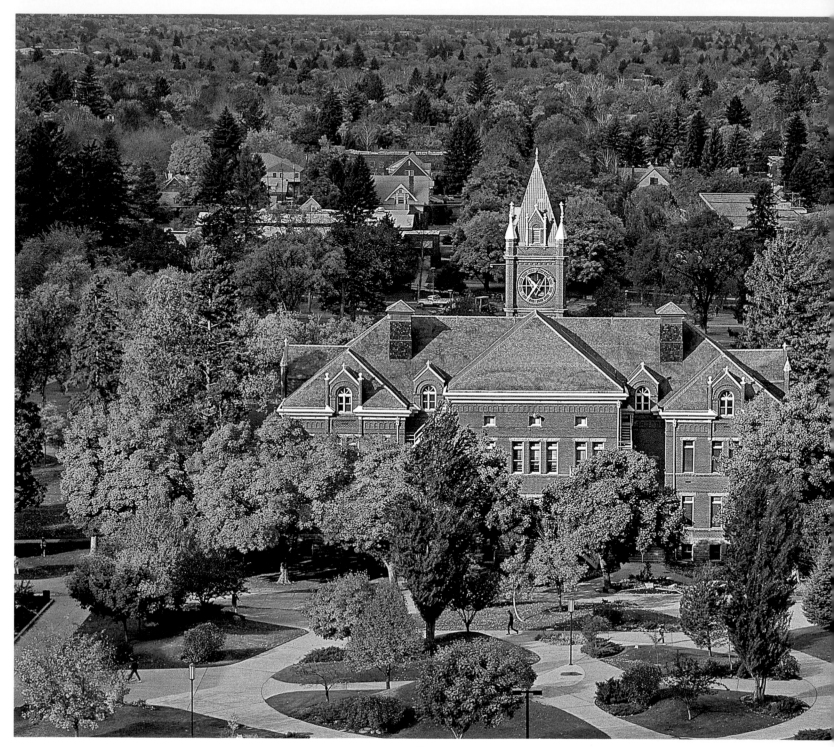

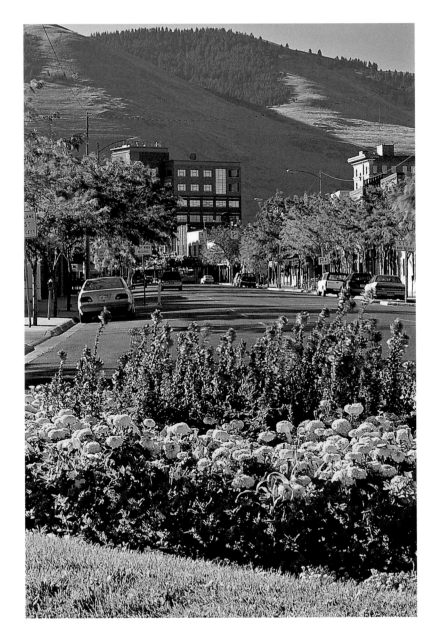

Left: Flowers in bloom on Front Street welcome visitors to Missoula's downtown district.

Far left: The University of Montana's Main Hall, built in 1898, is the centerpiece of the historic campus. The bells of the clock tower can be heard on campus and beyond as they toll every half-hour.

Right: Holland Lake, northeast of Missoula in the Swan Valley, rests in a chain of pristine mountain lakes between the east slope of the Mission Mountains and the west slope of the Swan Range. PHOTO BY DONNIE SEXTON / TRAVEL MONTANA

Below: Holland Lake Falls gracefully descends between Holland Lake and Upper Holland Lake at the threshold of the Bob Marshall Wilderness.
PHOTO BY TRAPPER BADOVINAC / SHOOTINGSTARPUBLICATIONS.COM

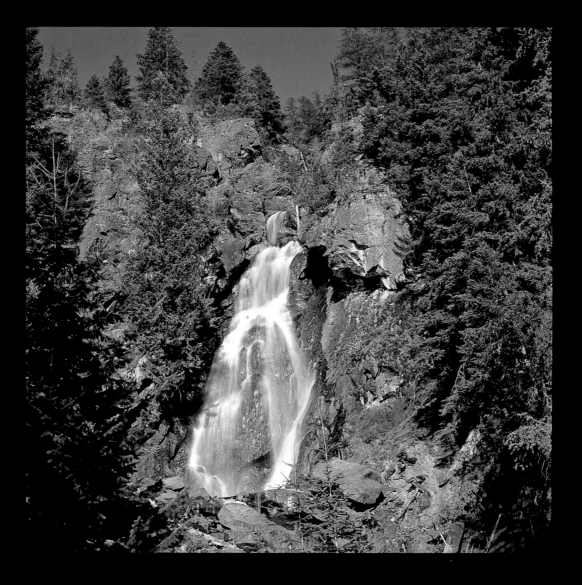

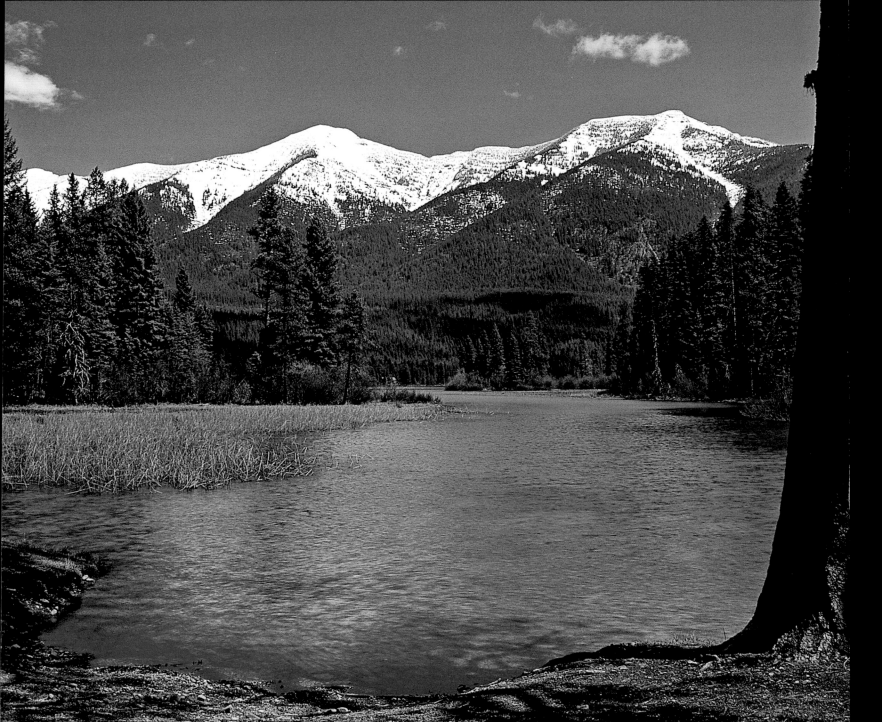

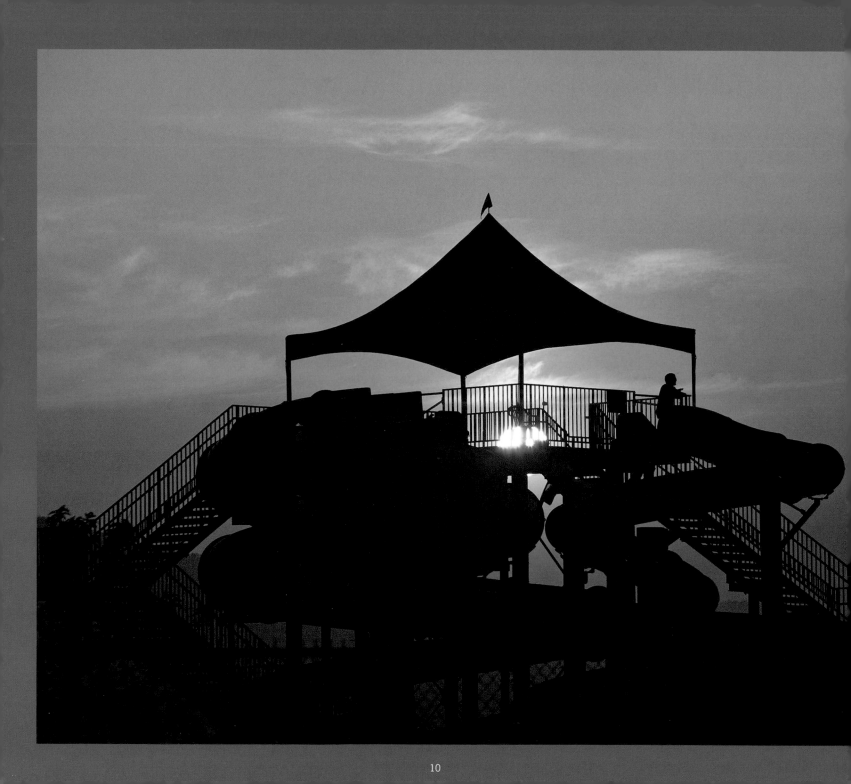

Left: The summer sun sets on Splash Montana, a public waterpark featuring waterslides, splash decks, and a lazy river. Waterparks were renovated throughout Missoula in 2006 and continue to energize visitors of all ages.

Below: MOBASH Skatepark was another 2006 addition to public recreation facilities that contributes to Missoula's high quality of living for families and youth.

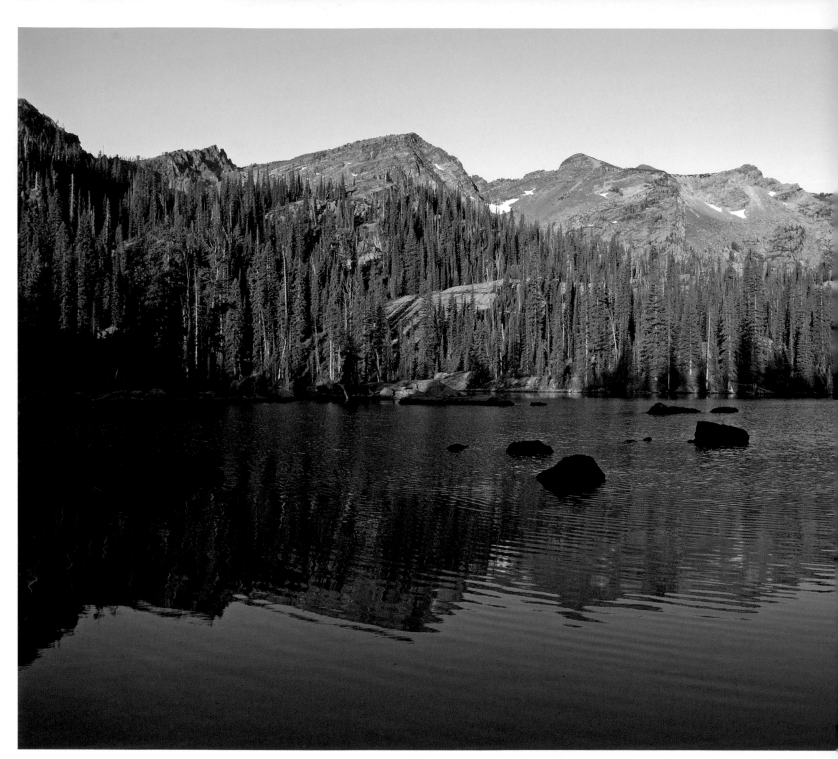

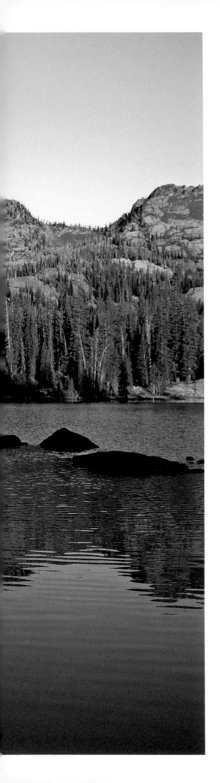

Left: Heart Lake shimmers in the Mission Mountains Wilderness. The adjacent Mission Mountains Tribal Wilderness, designated by the Confederated Salish and Kootenai tribes in 1979, is a traditional sacred area.

Below: Rattlesnake Creek flows south to Missoula from the 60,000-acre Rattlesnake National Recreation Area and Wilderness, where deer, elk, mountain goats, and black bears live just minutes from downtown.

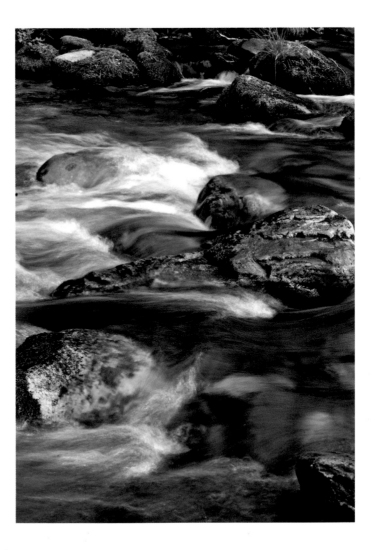

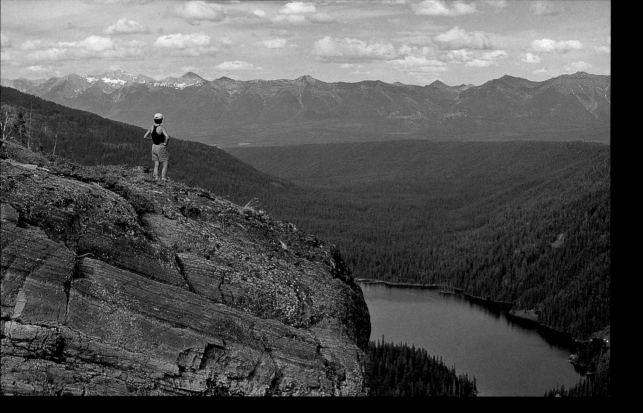

Above: Glacier Lake is a popular excursion for day hikers in the Mission Mountains, with views of the Swan Range in the distance.

Right: At the National Bison Range, 12,000-year-old beach lines from Glacial Lake Missoula leave clues to a lake that covered the valleys of western Montana during the last ice age. Catastrophic floods rushed to the Pacific Ocean as waters burst through an ice dam, carving gorges and leaving giant ripple marks through Idaho, Oregon, and Washington.

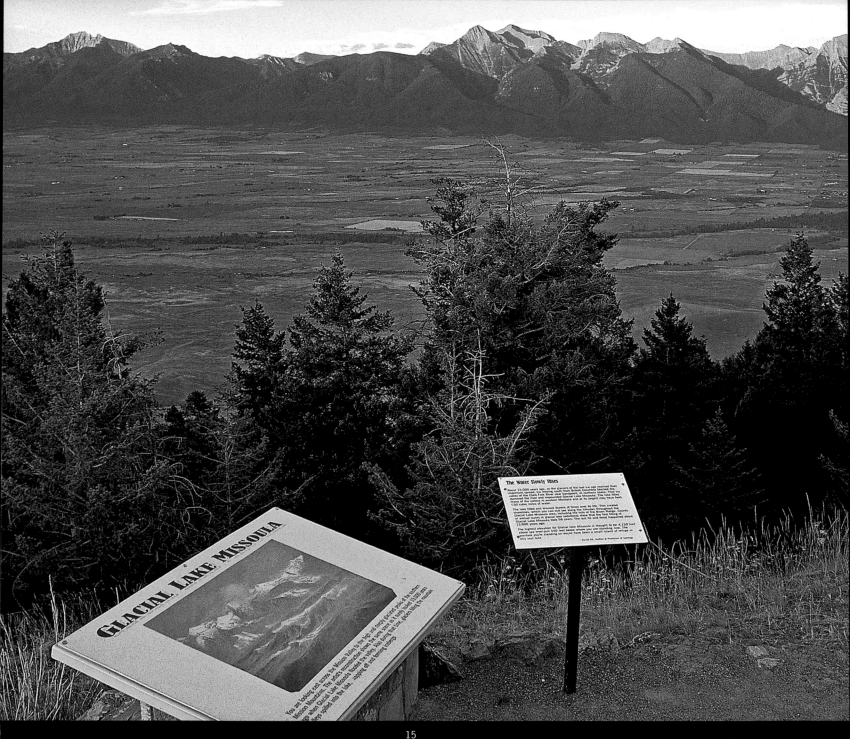

GLACIAL LAKE MISSOULA

You are looking out across the Mission Valley to the rugged and steeply faceted peaks of the northern Mission Mountains. The artist's reconstruction shows the same scene as it surely looked 13,000 years ago when Glacial Lake Missoula flooded the valley. You are seeing the icy, glacier-fed waters as it crashes spilled into the lake, lapping at old burning icebergs.

The Water Slowly Rises

About 15,000 years ago, as the glaciers of the last ice age reached their maximum spread, ice moving south from British Columbia blocked the valley of the Clark Fork River near Sandpoint, in northern Idaho. That ice dammed the river and impounded Glacial Lake Missoula. The lake filled many of the valleys in western Montana and at its largest may have held 530 cubic miles of water.

The lake filled and drained dozens of times over its life. This created shorelines, which you can still see along the hillsides throughout the Glacial Lake Missoula area, including the hills of the Bison Range. Counts of annual layers in glacial lake sediments show that the last filling of Glacial Lake Missoula took 58 years. The last fill and flood happened about 13,000 years ago.

The highest elevation for Glacial Lake Missoula is thought to be 4,150 feet above sea level—just 550 feet below where you are standing now. The greenhorn you're standing on would have been a small island of refuge in this vast lake.

—David Alt, Author & Professor of Geology

15

Right: Missoula's downtown street-lights are adorned with locally crafted, individually themed flower baskets throughout the summer months.

Far right: The Garden City's Farmers' Market is a lively Saturday event where you'll find local produce, baked goods, flowers, and people of all ages.

Below: Summer in Missoula is bright with flowers and the green of 3,500 acres of open space and parks.

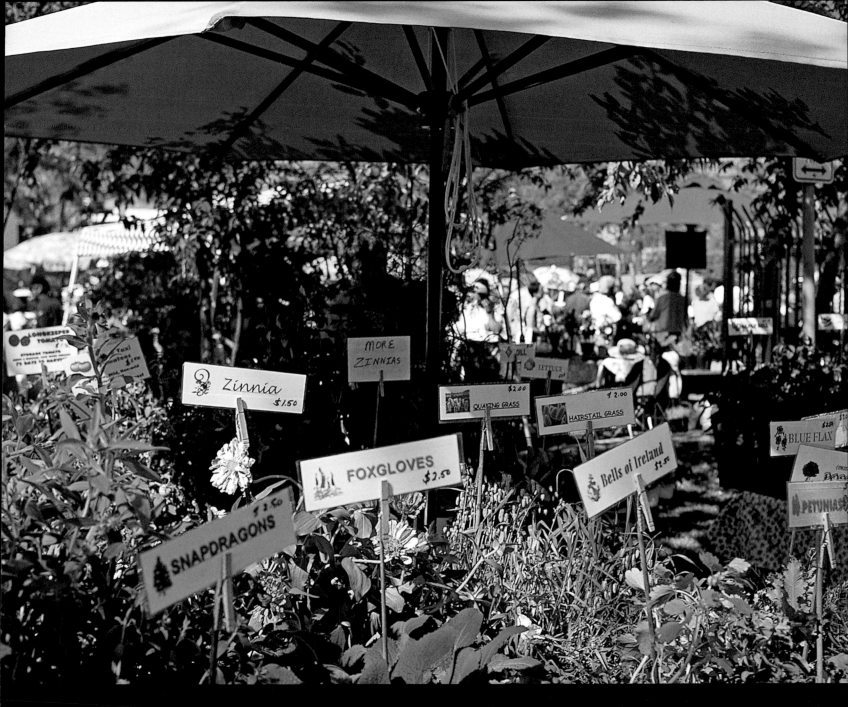

Right and far right: Montana's Salish and Pend d'Oreille tribes host the five-day Arlee Powwow, which began in the late nineteenth century. The annual celebration includes traditional drumming and singing, arts and crafts, competition dancing, and traditional, grass, fancy, and jingle dancing for men, women, and children.

PHOTO BY DONNIE SEXTON / TRAVEL MONTANA

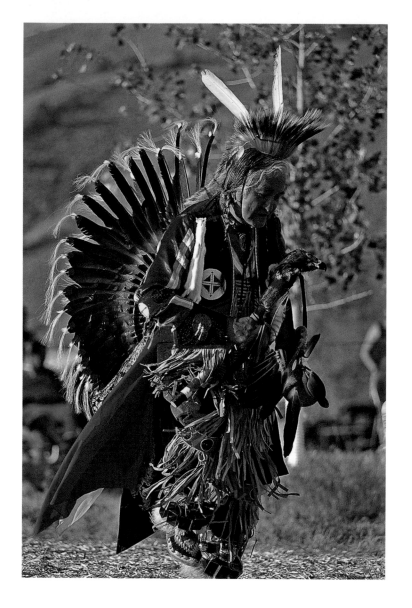

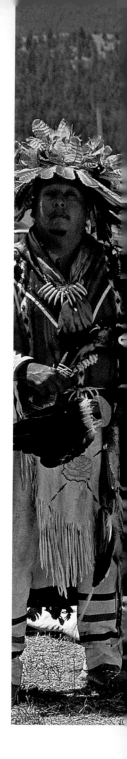

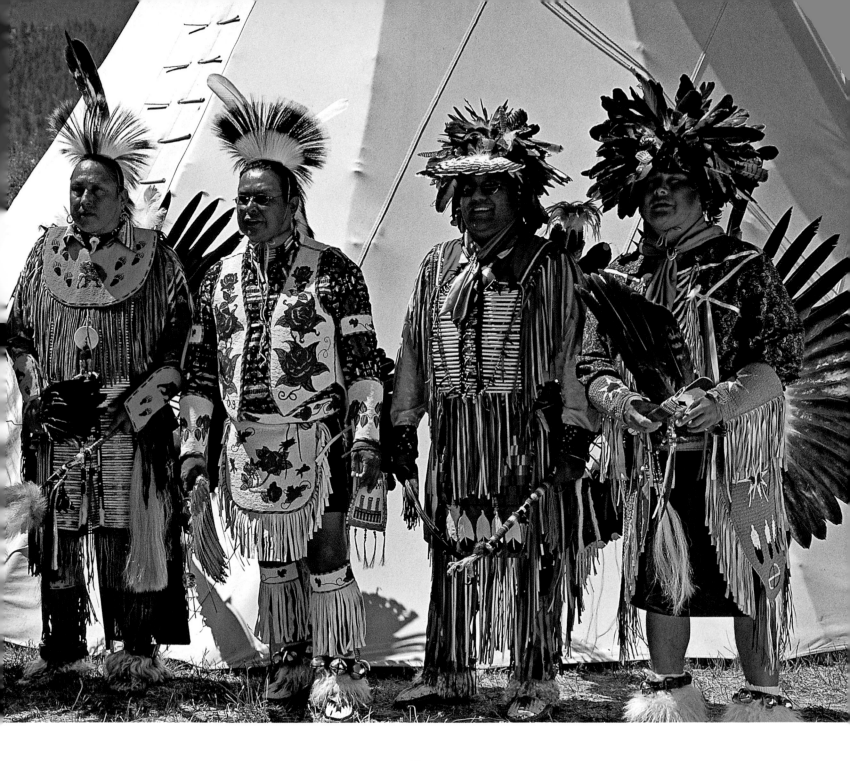

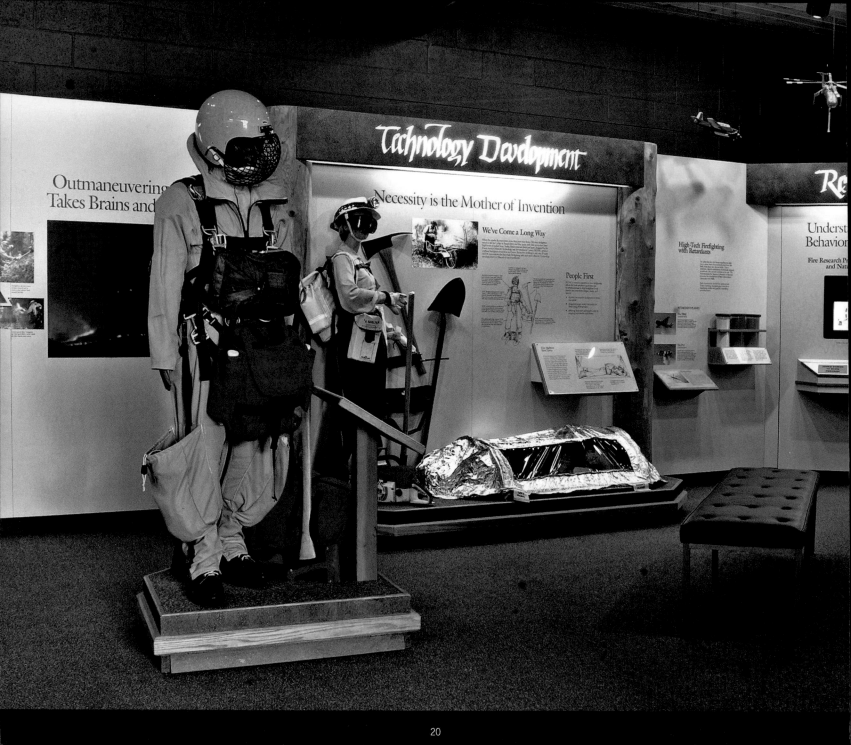

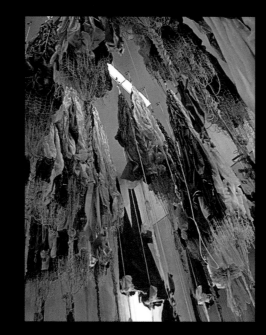

These pages: Visitors to the Smokejumper Visitor Center will find excellent displays on wildland firefighting before taking a behind-the-scenes tour of the largest smokejumper base in the nation. Gear in the ready room awaits the next fire call; parachutes hang before repacking as they have since the first jump in 1940.
PHOTOS BY DONNIE SEXTON / TRAVEL MONTANA

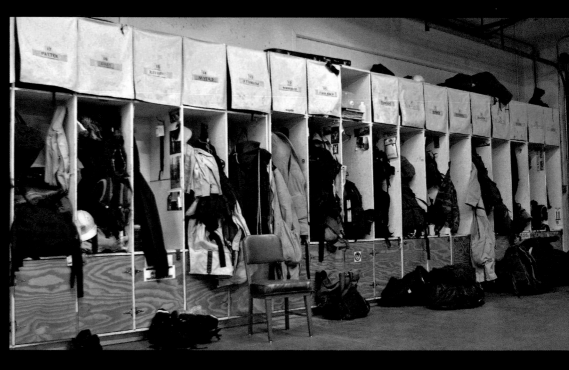

Right: Lolo Peak looms in the distance beyond the University Golf Course. The city's oldest course, it is often used during the off season for cross-country meets, skiing, sledding, and walking.

Below: The University "M" on Mount Sentinel is visible from a section of riverfront trail at Bess Reed Park.

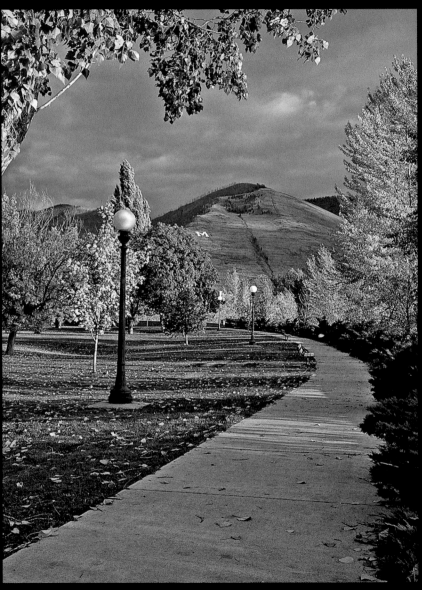

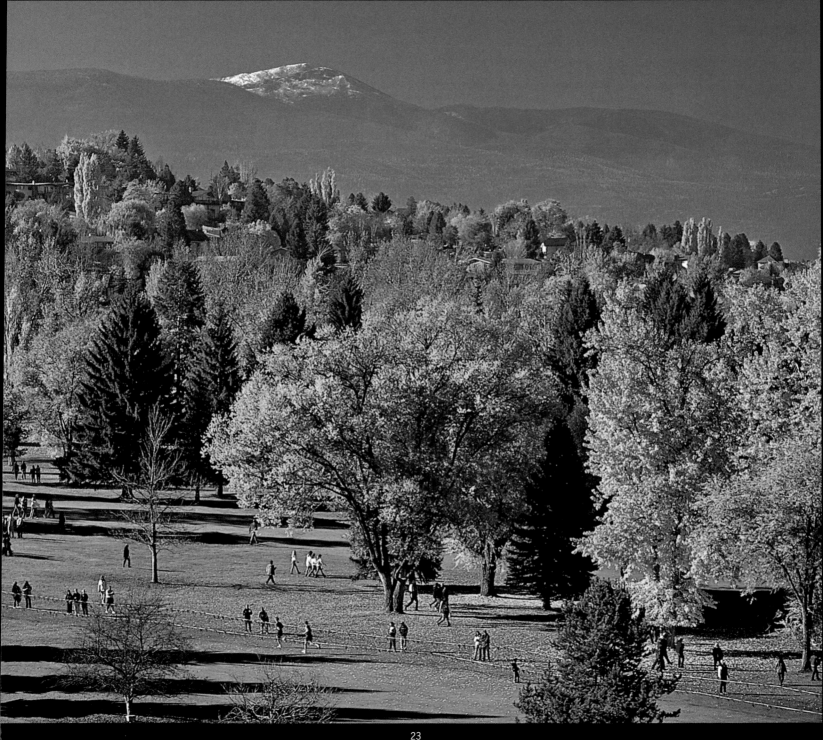

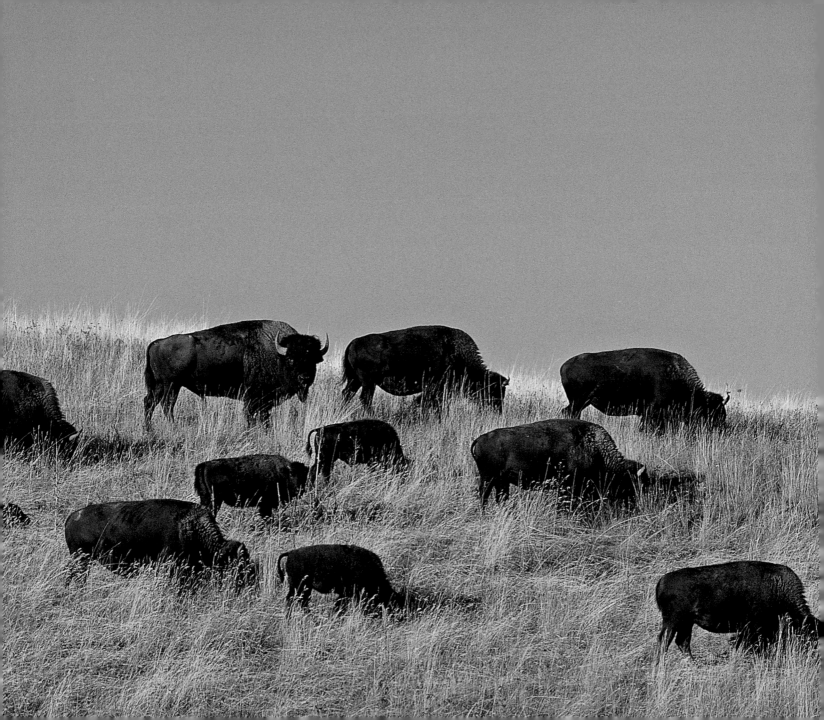

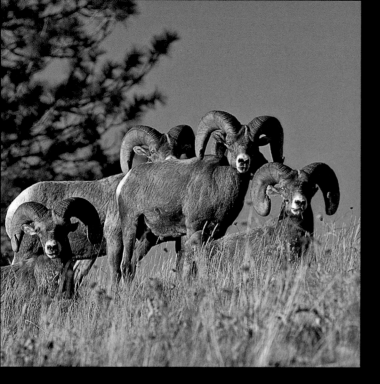

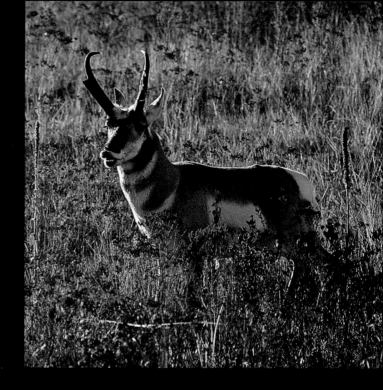

Above, left: Bighorn rams are very alert in the grassy meadows of the National Bison Range.

Above, right: Pronghorn antelope are North America's fastest land animal, capable of sprinting at speeds of up to seventy miles per hour.

Facing page: Bison, returned from the edge of extinction, graze at the 18,500-acre National Bison Range in the Mission Valley. Visitors can drive the nineteen-mile loop road through the reserve established in 1908 by President Theodore Roosevelt.

Right: Lupines and arrowleaf balsamroots bloom on Mount Jumbo above the Rattlesnake Valley.

Far right: The Blackfoot River, a tributary of the Clark Fork with its headwaters at the Continental Divide, is the inspiration for Norman MacLean's book and the movie *A River Runs Through It.*

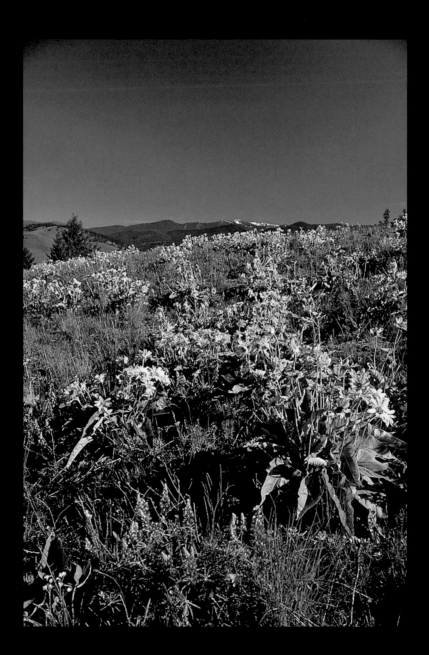

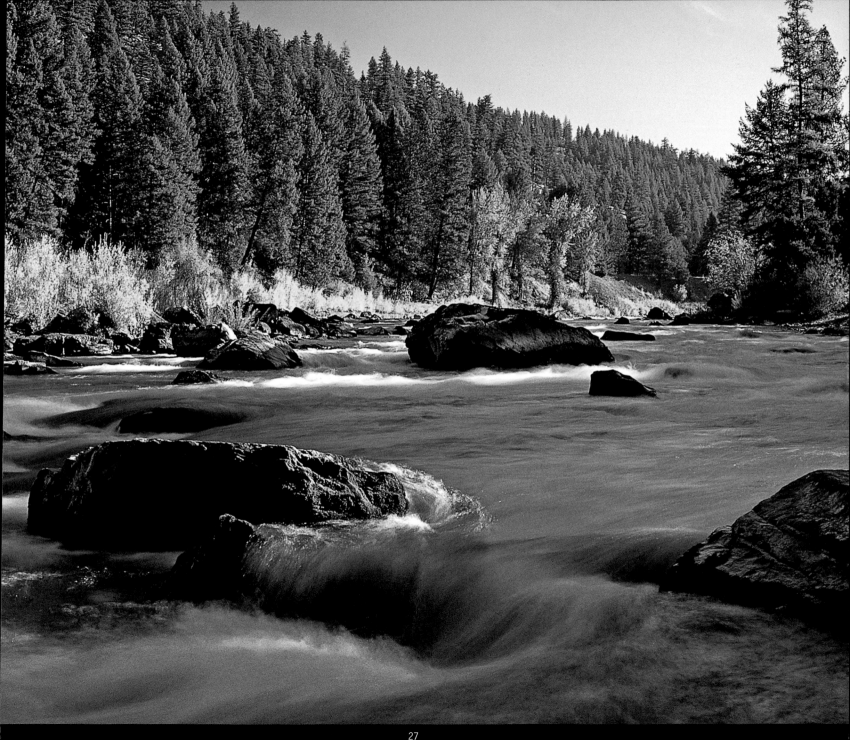

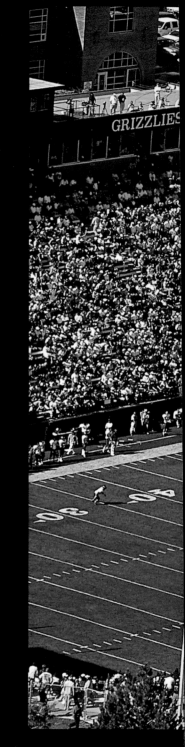

Right: The University of Montana's celebrated gridiron at Washington-Grizzly Stadium regularly draws more than 25,000 fans. "The Griz" have several national championships on record. Touchdowns are celebrated with the blast of a real Army cannon.

Below: "Out to Lunch" in Caras Park is an every-Wednesday community event during the summer months, featuring food vendors and live music on the riverfront.

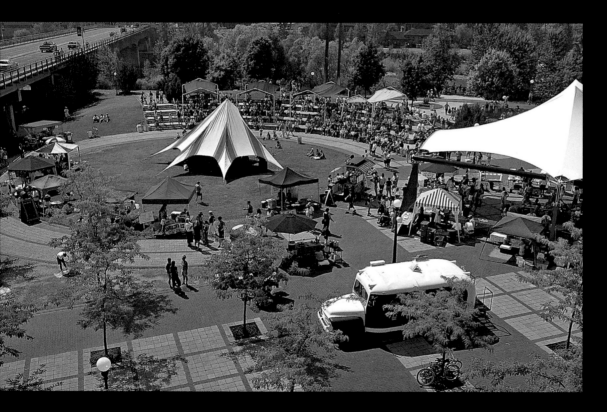

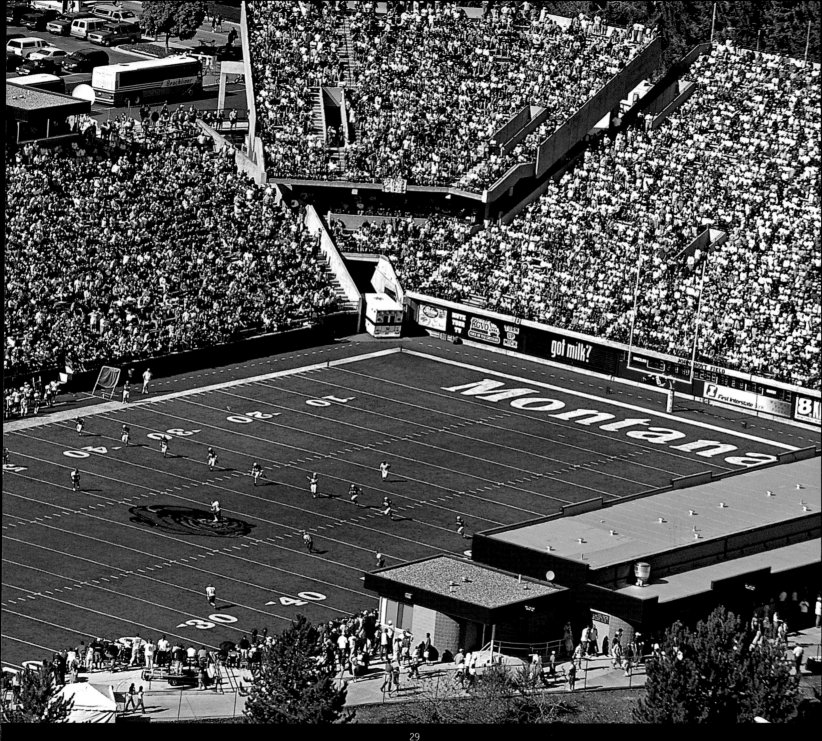

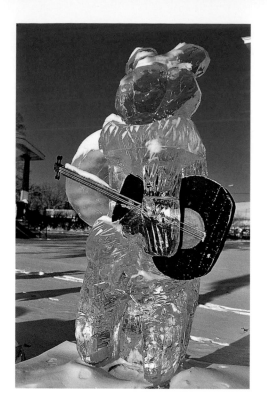

Right: An ice sculpture remains for weeks after the First Night celebration.

Far right: Skiers at Montana Snowbowl often enjoy sunny days above a socked-in Missoula Valley. Skiing 950 acres of lift-accessed runs helps build up an appetite for Snowbowl's hand-tossed pizza, baked in a wood-fired oven.
PHOTO BY WWW.JOHNNYPATTERSON.COM

Below: Winterfest, an annual celebration of snow and winter activities in the Seeley-Swan Valley, includes a pancake breakfast, sled dog race, biathlon, broomball games, and snow- and ice-sculpture competitions.

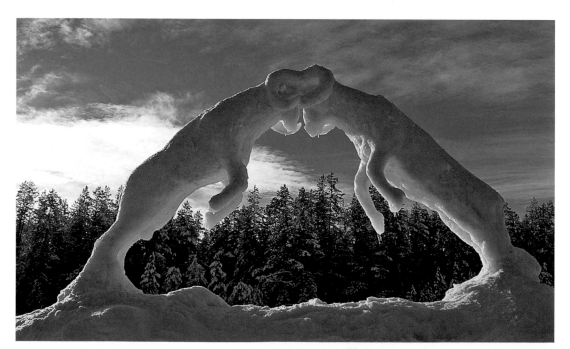

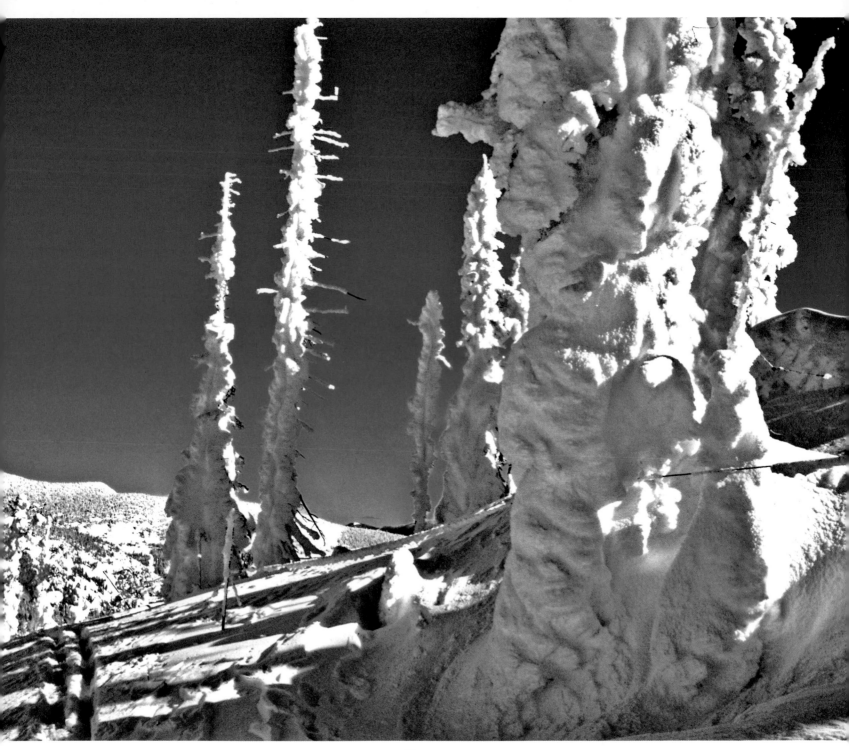

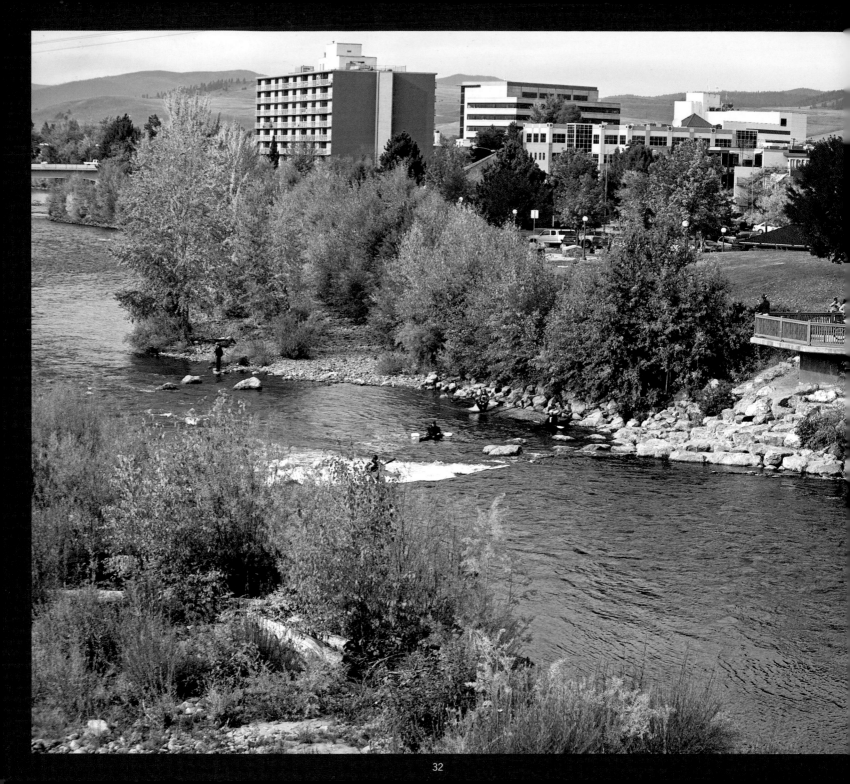

Left: Caras Park connects a bustling downtown to the riverfront, offering a viewing deck above Brennan's Wave.

Below: Built in 2006, Brennan's Wave draws kayakers every month of the year to surf the waves in the Clark Fork River. It was named in memory of Missoula's own world-class kayaker, Brennan Guth.

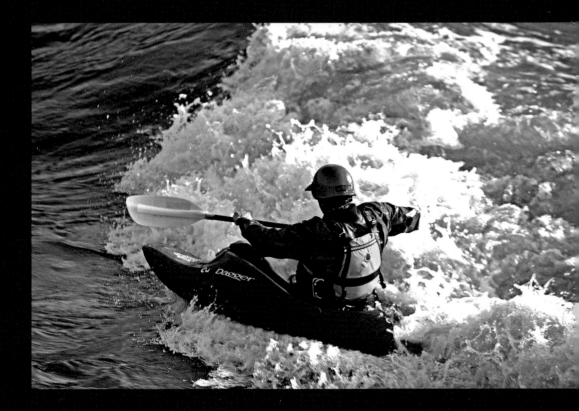

Right: The St. Ignatius Mission was founded in 1854 by Jesuit missionaries on what is today the Flathead Indian Reservation. Remarkable frescoes painted in the early 1890s grace the chapel at the foot of the Mission Mountains.

Below: St. Mary's Mission, founded in 1841, was closed when the Salish of the Red Willow Valley (today's Bitterroot Valley) were forced to move to a reservation in the Jocko Valley in 1891.

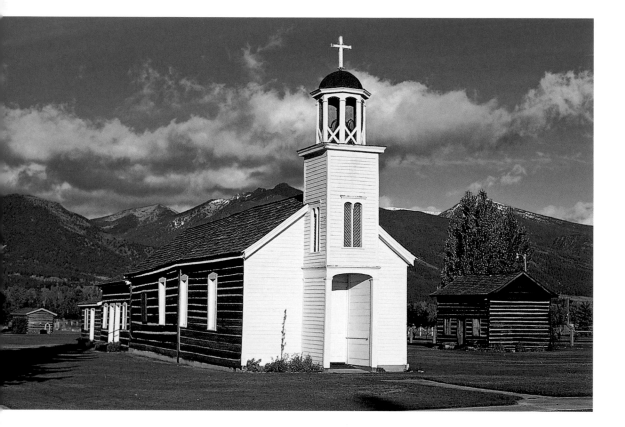

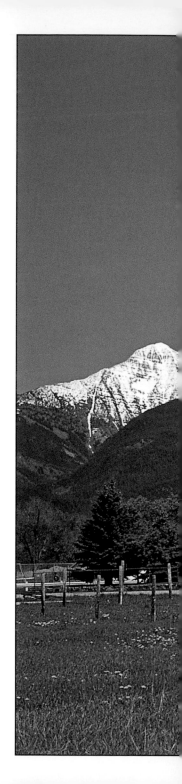

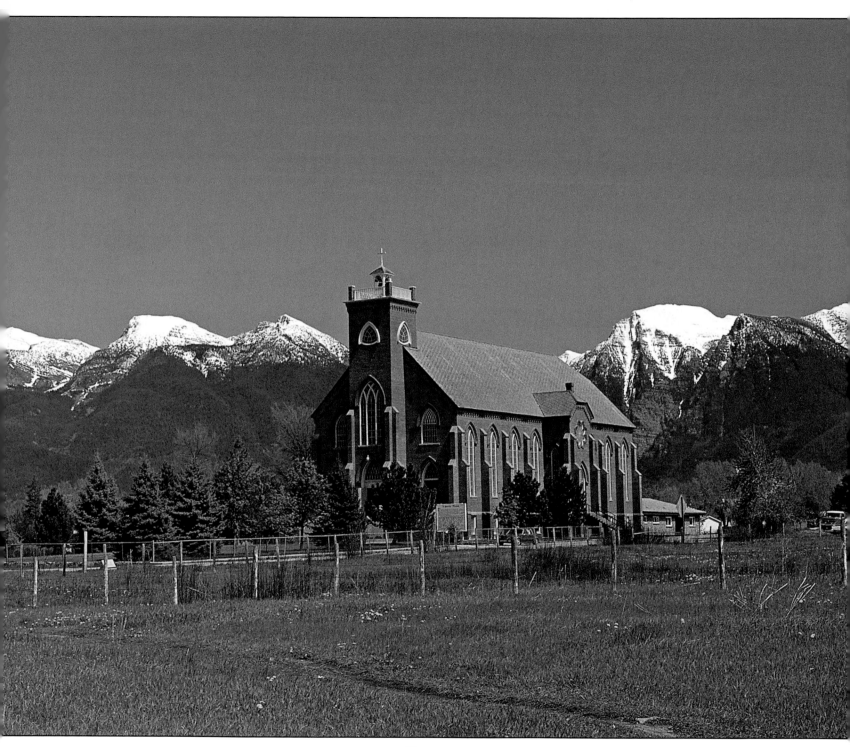

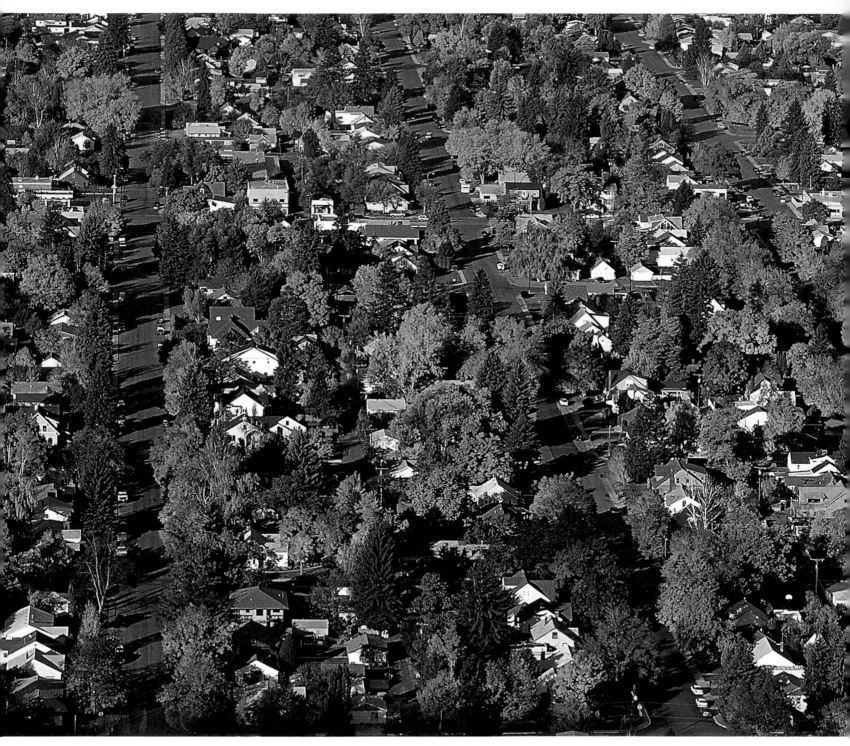

Left: Missoula's tree-lined streets date back to the late 1800s, when Norway maple seedlings were carried from New England by steam engine, paddleboat, and then ox-drawn wagon to Missoula. Today the city maintains an urban forest of more than 20,000 trees and repeatedly earns the designation of "Tree City USA" from the National Arbor Day Foundation.

Below: Fallen leaves from cottonwood, maple, elderberry, mountain ash, and snowberry trees can all be found in Rattlesnake Creek.

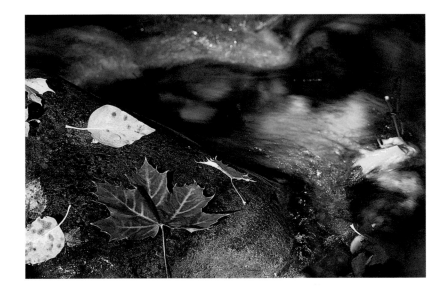

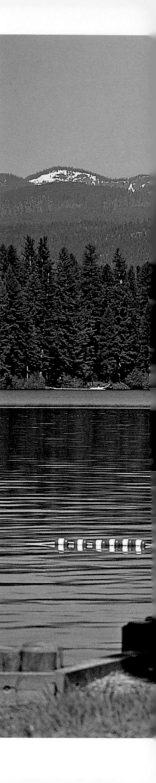

Right: Seeley Lake is ringed by vacation homes and is a favorite getaway for boating, waterskiing, and swimming. PHOTO BY DONNIE SEXTON / TRAVEL MONTANA

Below: Once used by Native Americans as a wintering area for horses, the mild climate of Plains and nearby Paradise is a haven for nurseries.

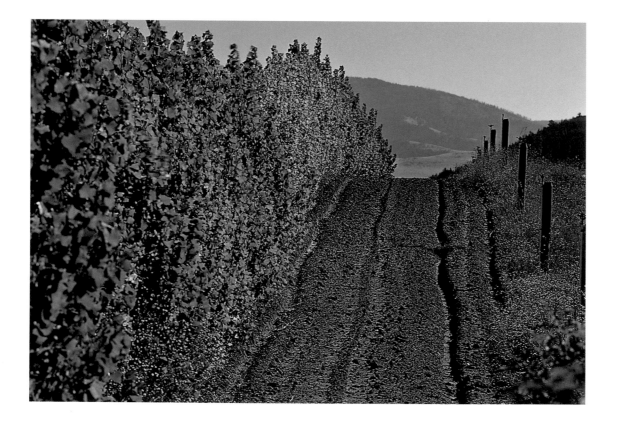

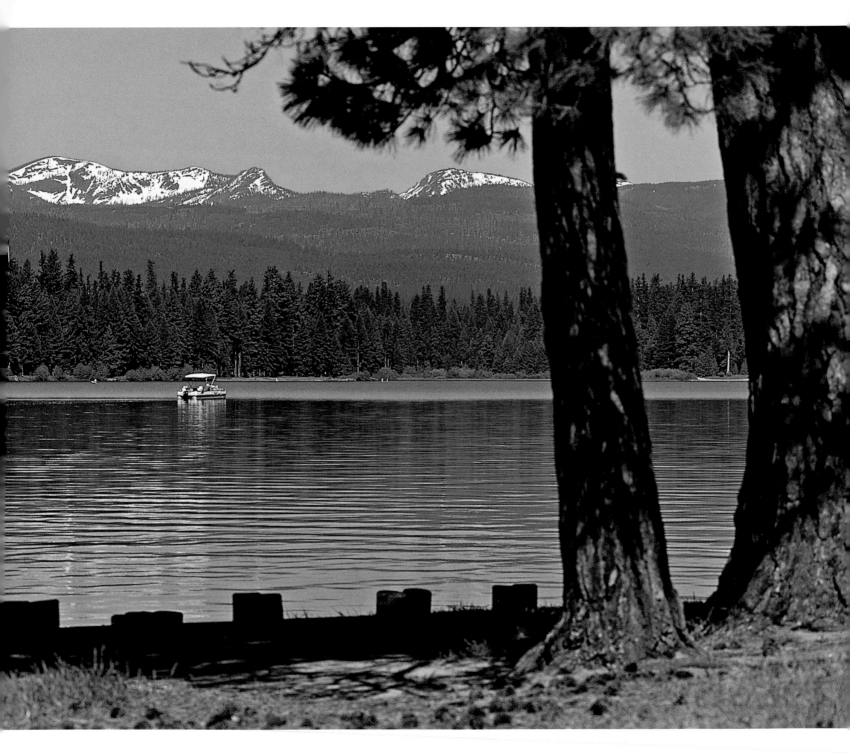

Right: Trapper Peak is the tallest peak in the Bitterroot Range, at 10,157 feet, standing on the eastern edge of the Idaho Batholith. The rugged granite peaks of the Bitterroots resulted from glacial weathering of 200-million-year-old granite.

Below: Abundant trails in the Bitterroot Mountains lead to sweeping vistas, waterfalls, and technical climbing routes.

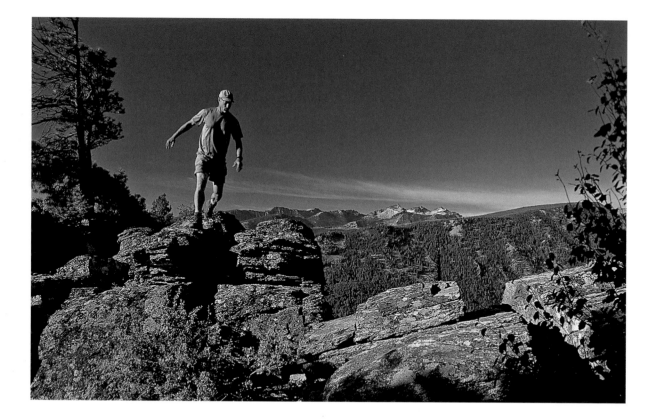

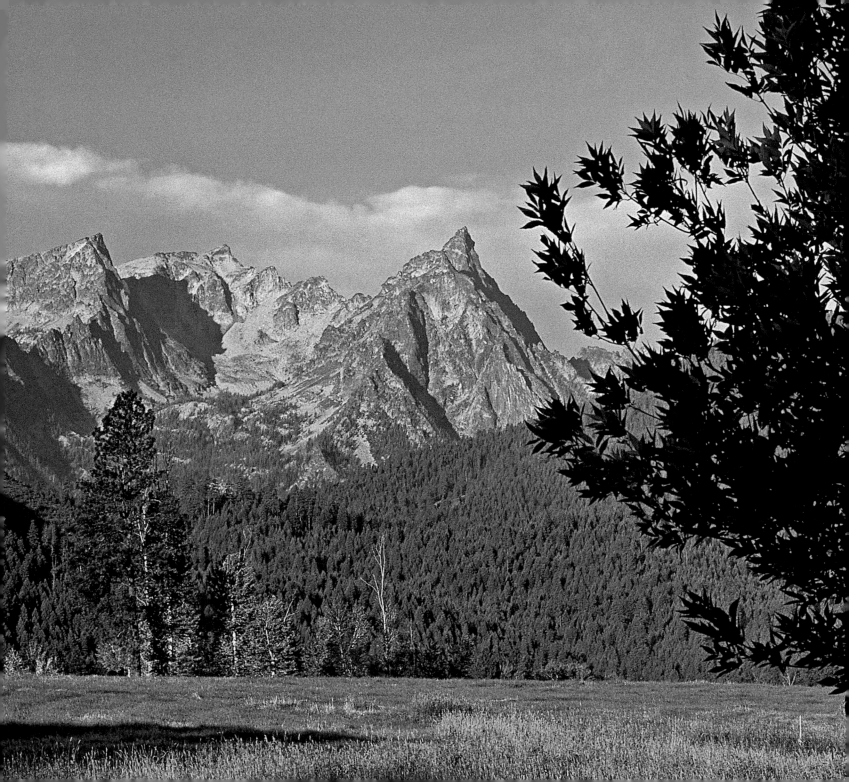

Right: "Tubing" is a free and easy way to enjoy a summer day on the Blackfoot River.

Far right: A backpacker sets off into the Bob Marshall Wilderness. There are 3.1 million acres of wilderness within a hundred-mile radius of Missoula.

Below: Skateboarding legend Tony Hawk christened Missoula's world-class community skatepark, MOBASH, in 2006.

Facing page: Missoula area anglers on the Bitterroot, Clark Fork, Missouri, and Blackfoot rivers cast for brook trout, brown trout, mountain whitefish, northern pike, rainbow trout, smallmouth bass, westslope cutthroat trout, and yellow perch.

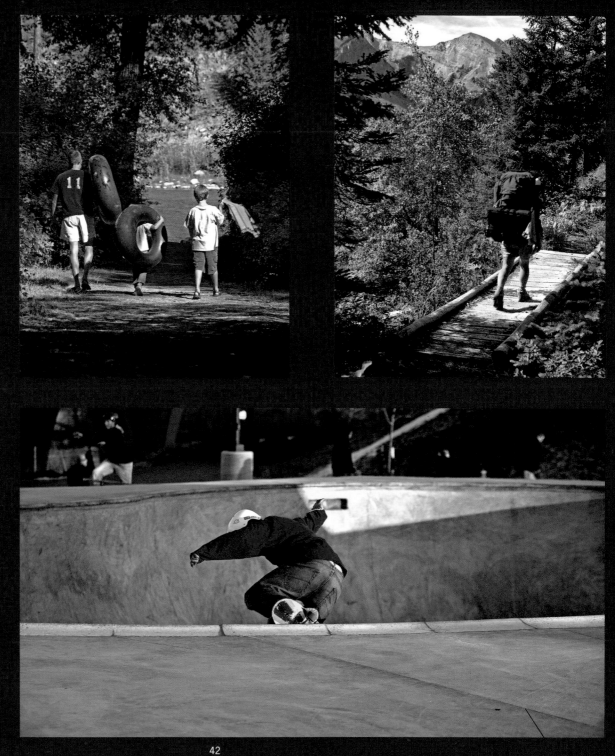

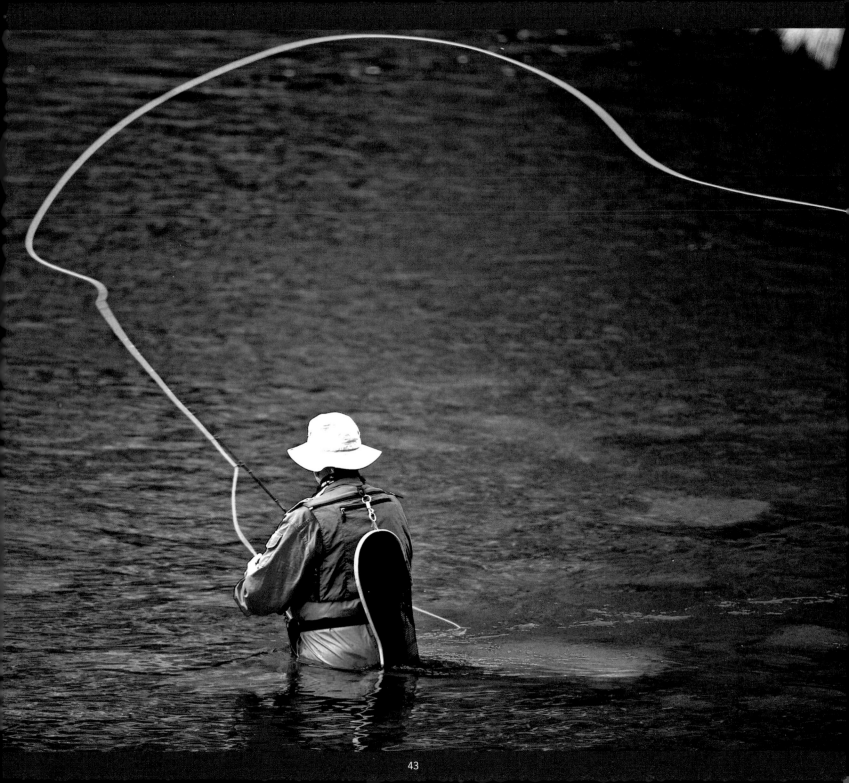

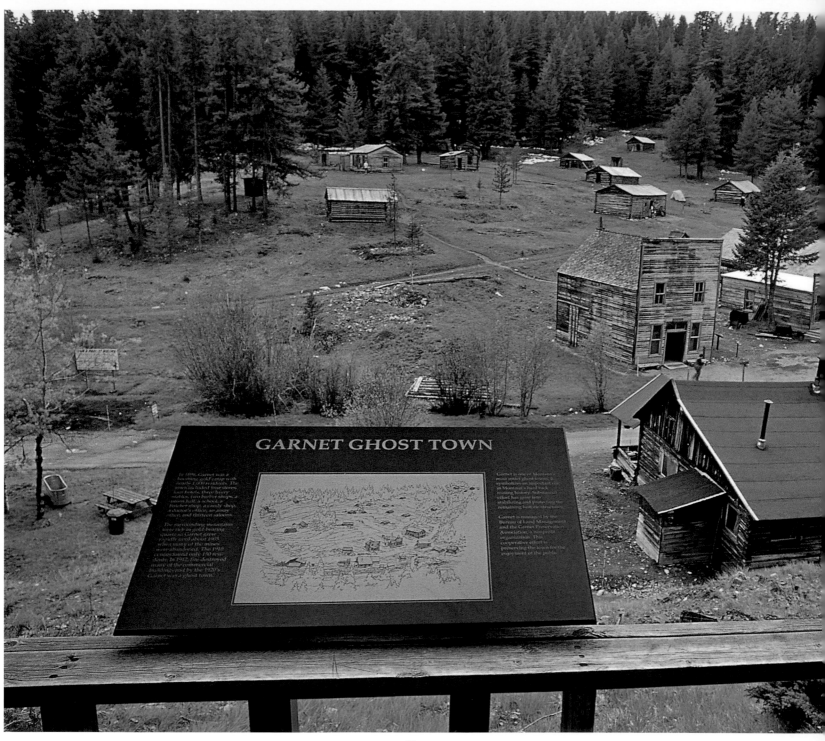

Left: Garnet ghost town dates back to 1895, when placer miners found gold in First Chance Gulch. At one time, hotels, saloons, stores, a school, and a Chinese laundry served the men laboring in more than fifty mines in the area.

Below: The U.S. Army established Fort Missoula southwest of Missoula in 1877 to protect settlers from native Indian tribes. It later hosted the all-black 25th Infantry Bicycle Corps, an Italian and Japanese-American internment camp, and the regional headquarters of the Civilian Conservation Corps. Today it is home to the Historical Museum at Fort Missoula and this historic Army cemetery.

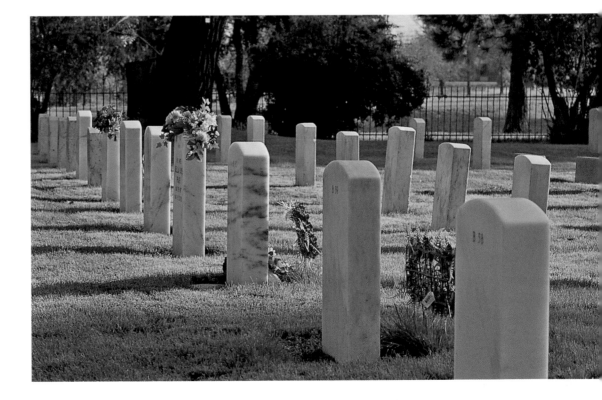

Right: The Lolo Pass visitor center is a winter trailhead for groomed cross-country skiing and snowmobiling. Hardy outdoors enthusiasts also take off from this point, for adventures in backcountry ski mountaineering.

Far right: Snow covers the peaks of Montana's Mission Mountains in winter. Sacred vision quest sites north of McLeod Peak and the Rattlesnake Divide are open to tribal members only.

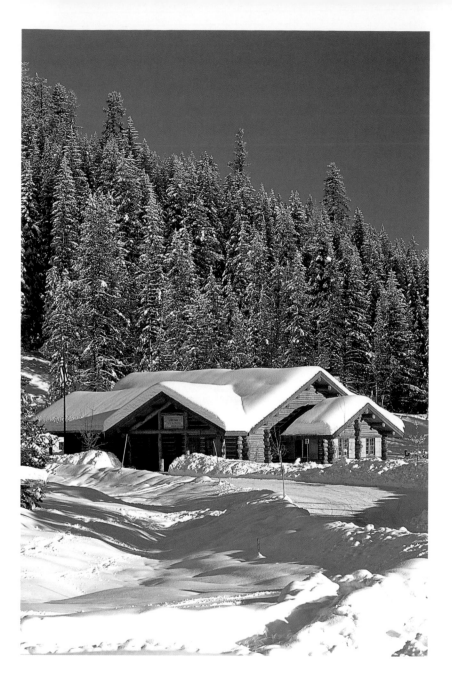

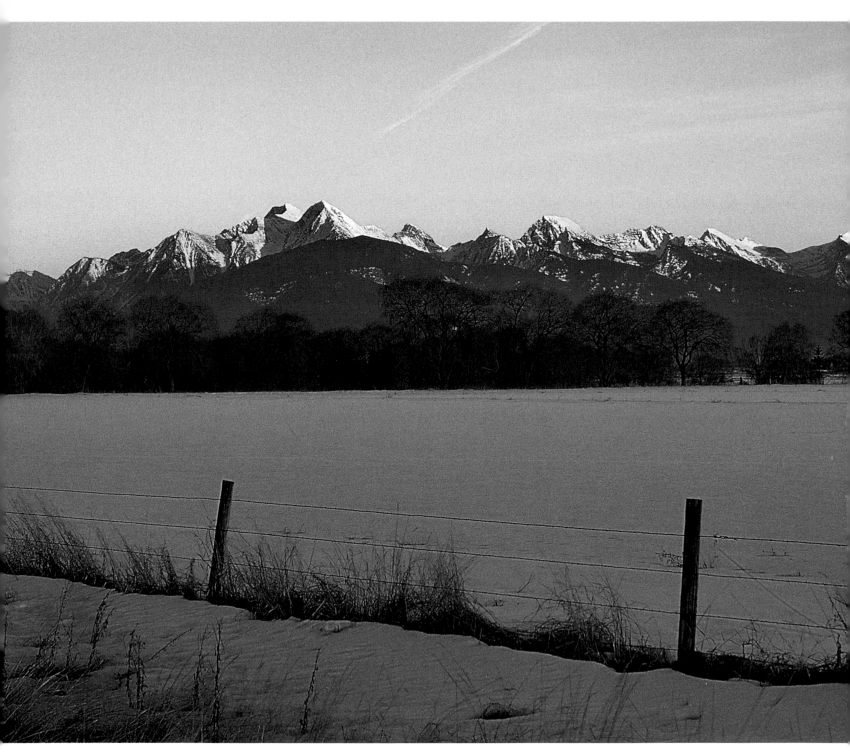

Right and below: The Georgian-Revival–style Daly Mansion was home to Marcus Daly, one of Montana's famed "copper kings." An Irish immigrant, Daly transformed Butte's Anaconda Mine into a copper empire. He died in 1900 amidst his legendary and corrupt struggle against copper king William Clark, while attempting to win the capital seat for Anaconda. PHOTOS BY DONNIE SEXTON / TRAVEL MONTANA

Far right: One of Missoula's many bike commuters travels the riverfront trail underneath the Orange Street bridge.

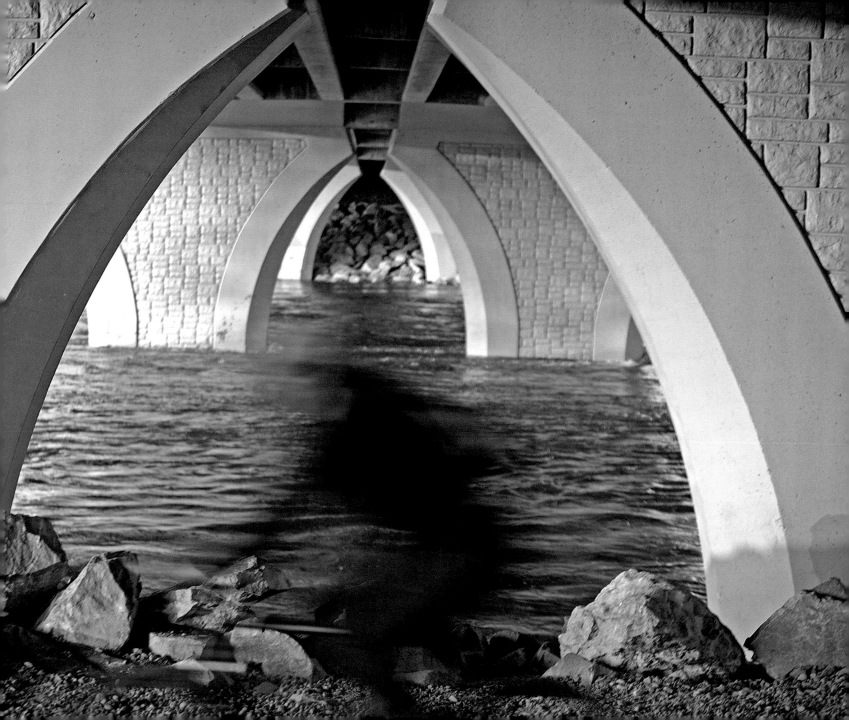

Below: The intelligent American black bear lives throughout the forests of the five valleys. Black bears are also spotted roaming in Missoula's historic Rattlesnake neighborhood.

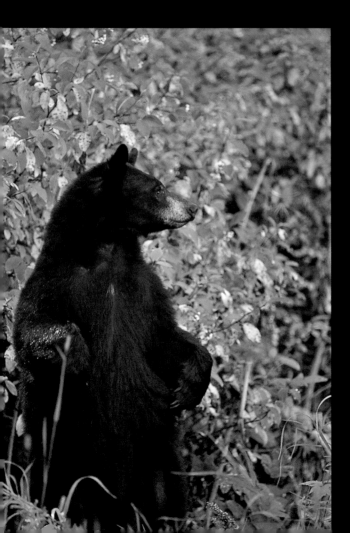

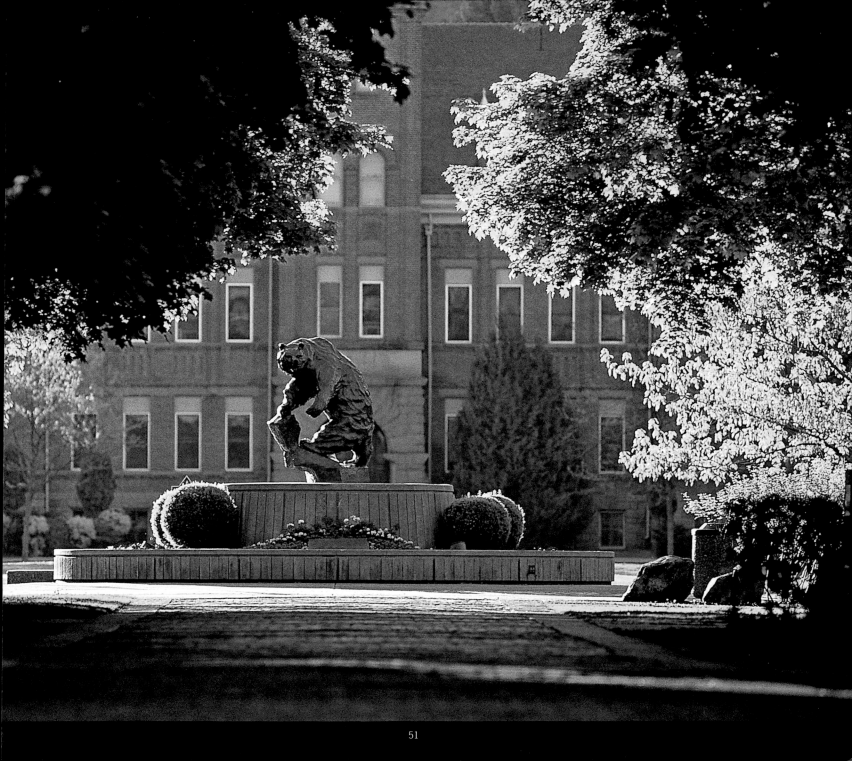

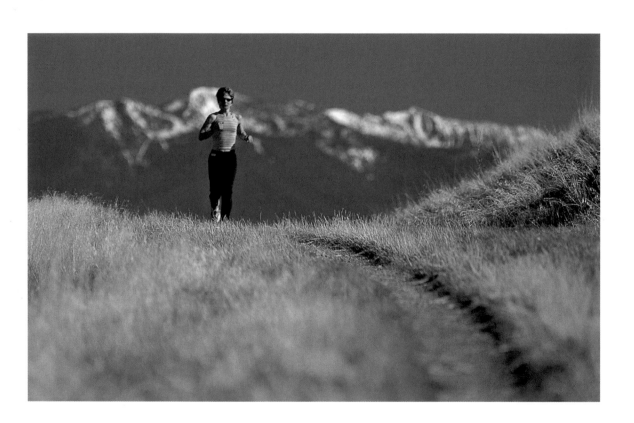

Above: A jogger on Mount Sentinel heads back toward Pattee Canyon and the Crazy Canyon trail system.

Right: A photographer captures the beauty of a clear day overlooking Trapper Peak in the Bitterroot Range.

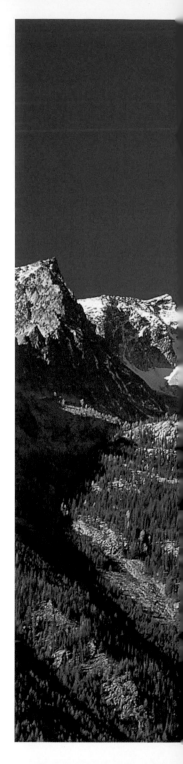

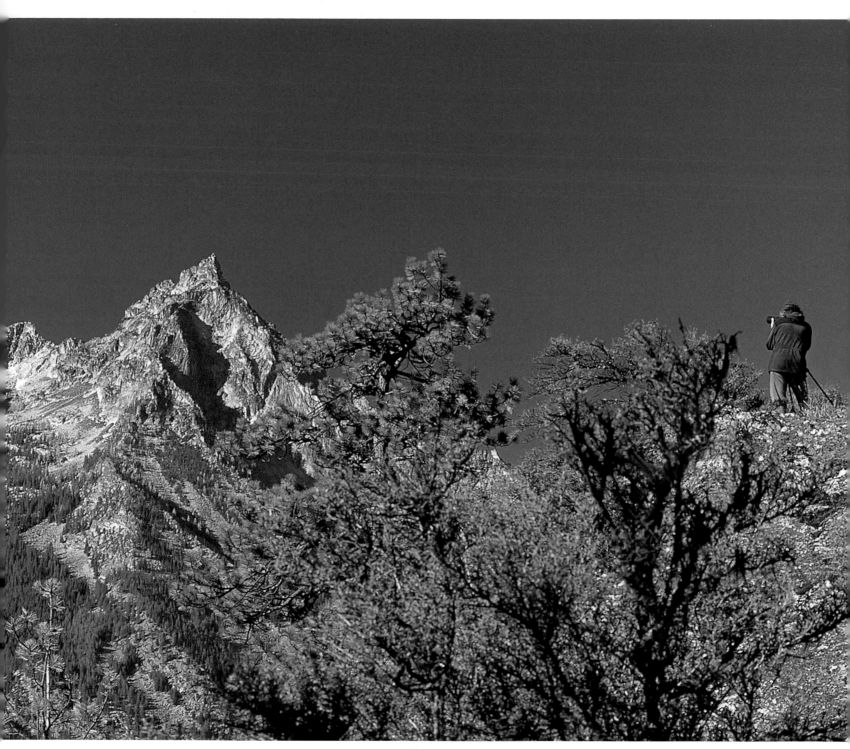

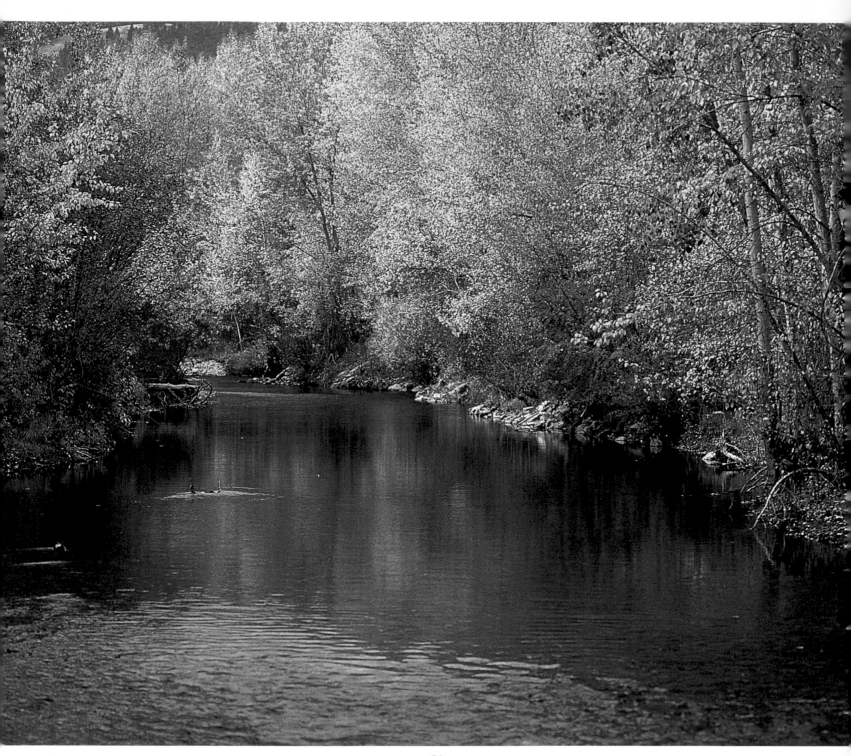

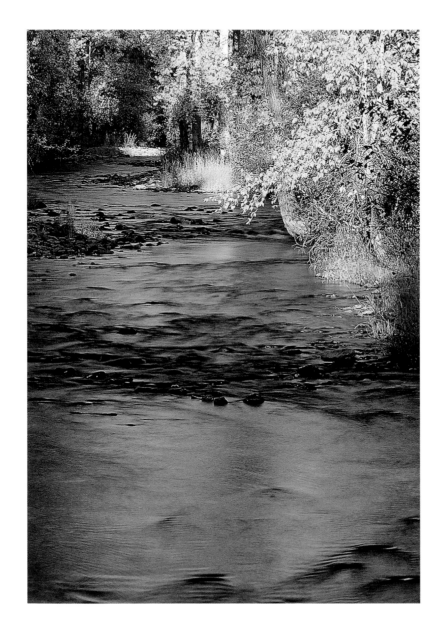

Left: Nine Mile Creek is an important spawning stream that flows into the Clark Fork River just east of Alberton.

Far left: In 1905 and 1906, Lewis and Clark camped on Lolo Creek at Travelers' Rest, a centuries-old Native American campsite. Archaeologists discovered unique physical evidence of the Corps of Discovery's camp in 2002.

Right: The Water-Wise Garden is a "living laboratory" of water-conserving plants and land-scape design that survives on Missoula's average of thirteen inches of precipitation per year.

Far right: Late spring snowfall dusts the top of Mount Sentinel, where the receding shoreline of Glacial Lake Missoula, of 12,000 years ago, is still evident.

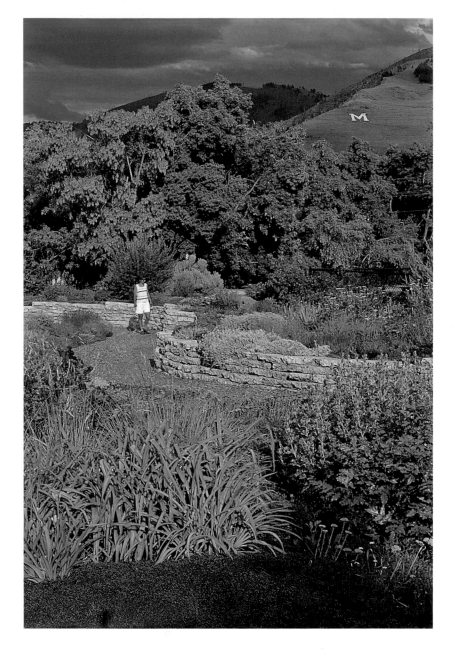

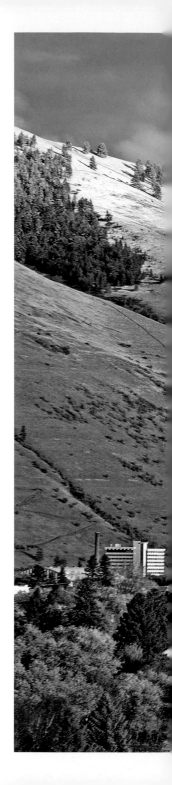

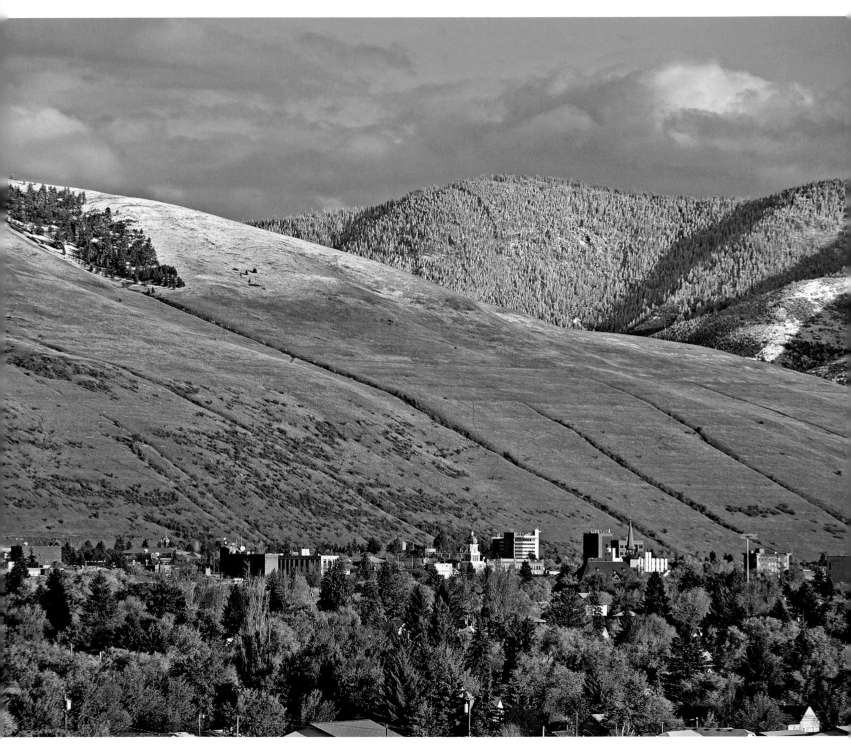

Right: The Rolling Stones rocked a sold-out Washington-Grizzly Stadium in October 2006 with their ninety-two-foot-high backdrop—likely the biggest show to ever hit Montana.

Below: The Wilma Theatre sends a glowing reflection across the Clark Fork River. The 1,066-seat Louis XIV-style theatre has been hosting events since the theater was completed in 1921.

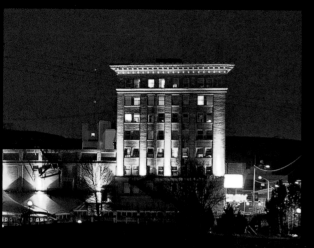

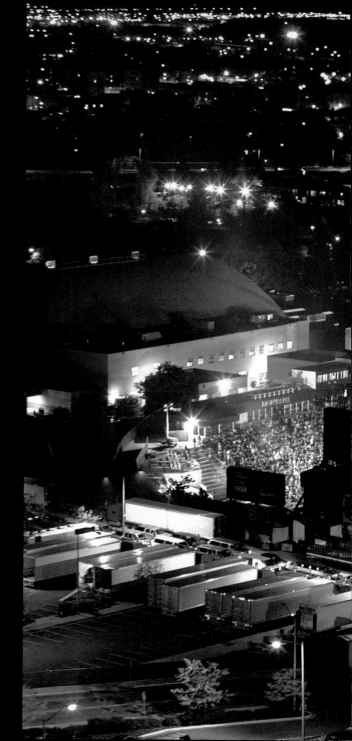

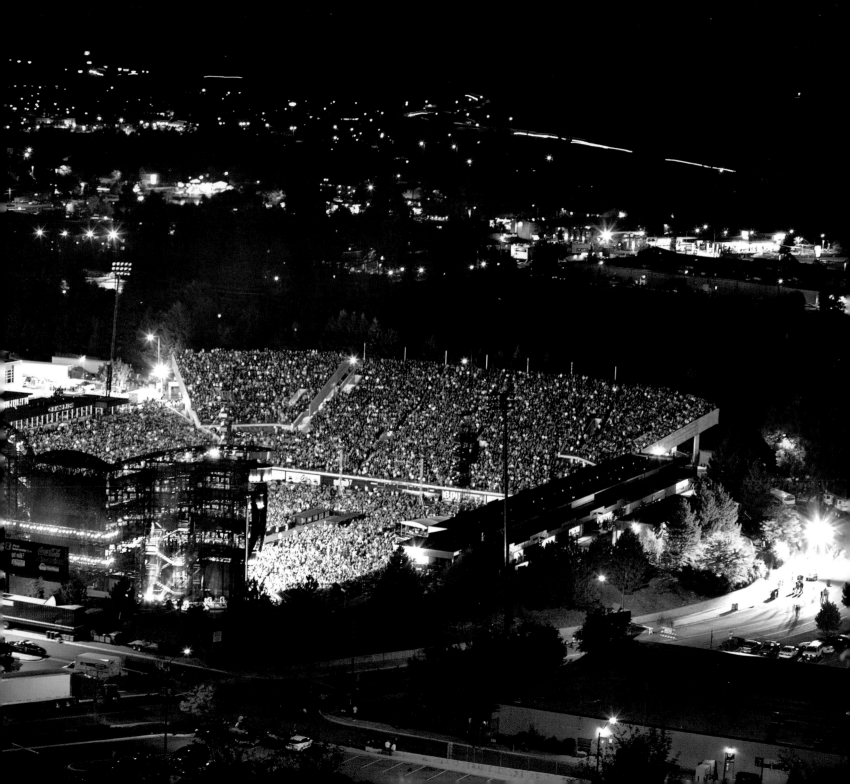

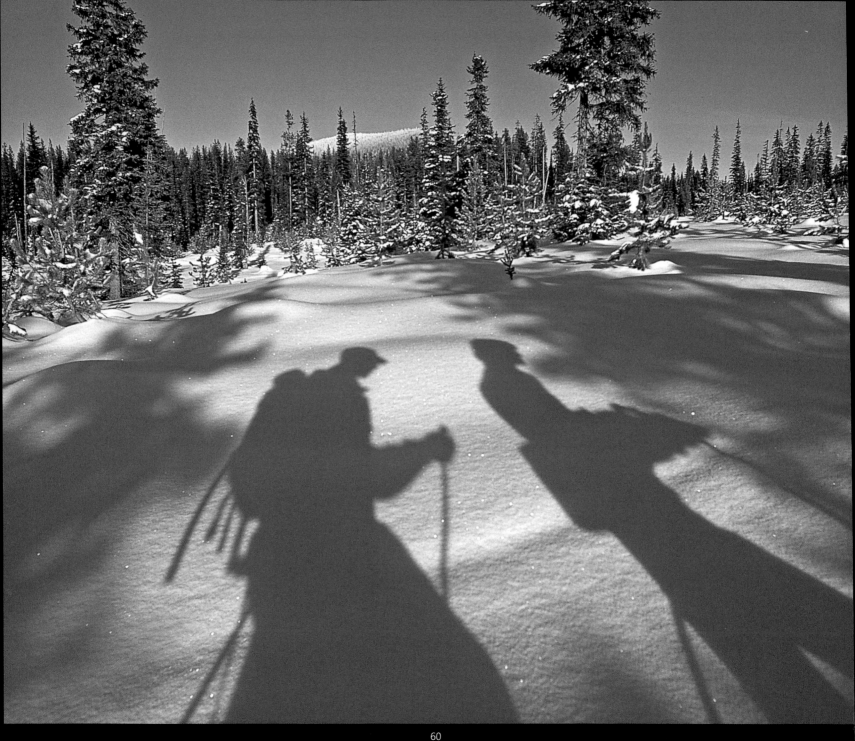

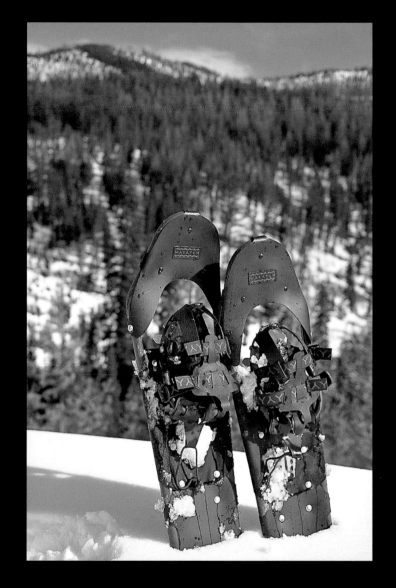

Left: Snowshoeing is a fun way to get outdoors during the long winter months.

Far left: Snowshoers at Lolo Pass enjoy a sunny day in the Bitterroot Mountains, a range more than 470 miles long.

Right: Hikers above Rock Creek enter the steep, narrow valleys of the Welcome Creek Wilderness, where a gold nugget weighing one-and-a-half pounds was found in 1888.

Far right: Overnight trips leave plenty of time for fishing the Blackfoot River, one of twelve Montana "blue ribbon" streams. About forty percent of outfitted trips in Montana are for fishing.

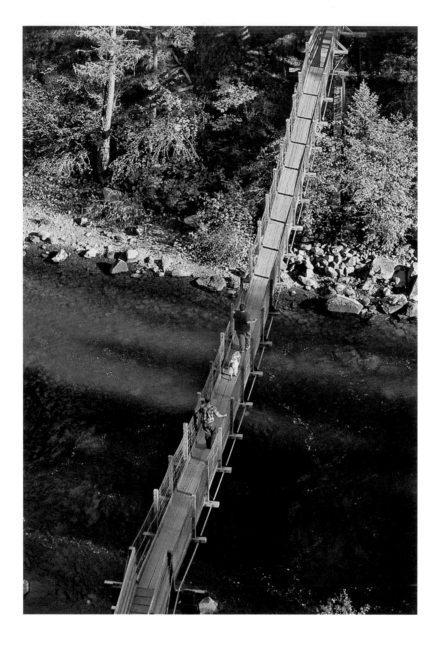

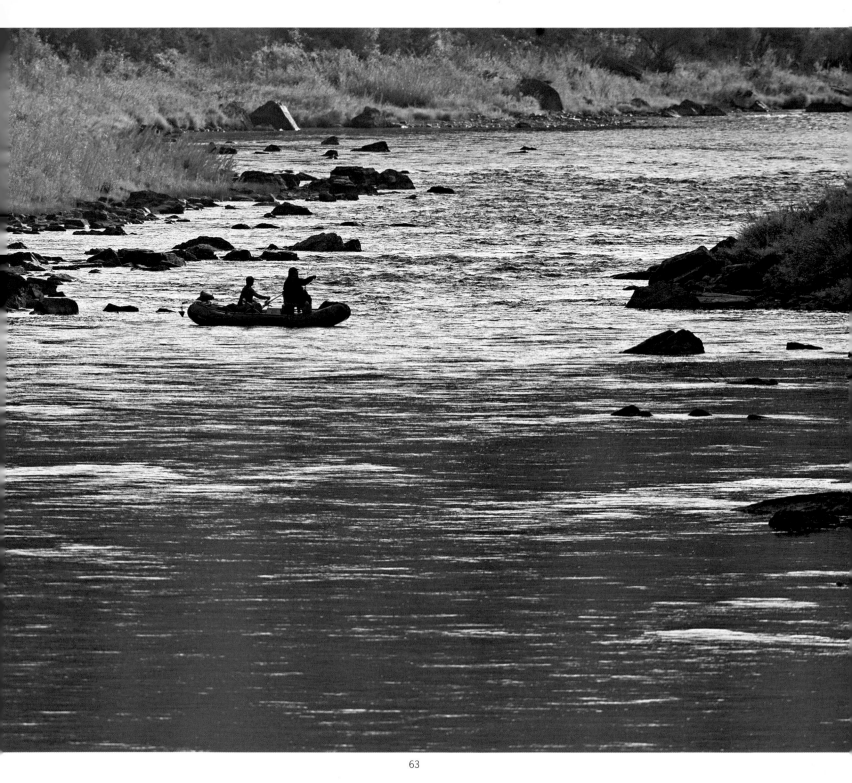

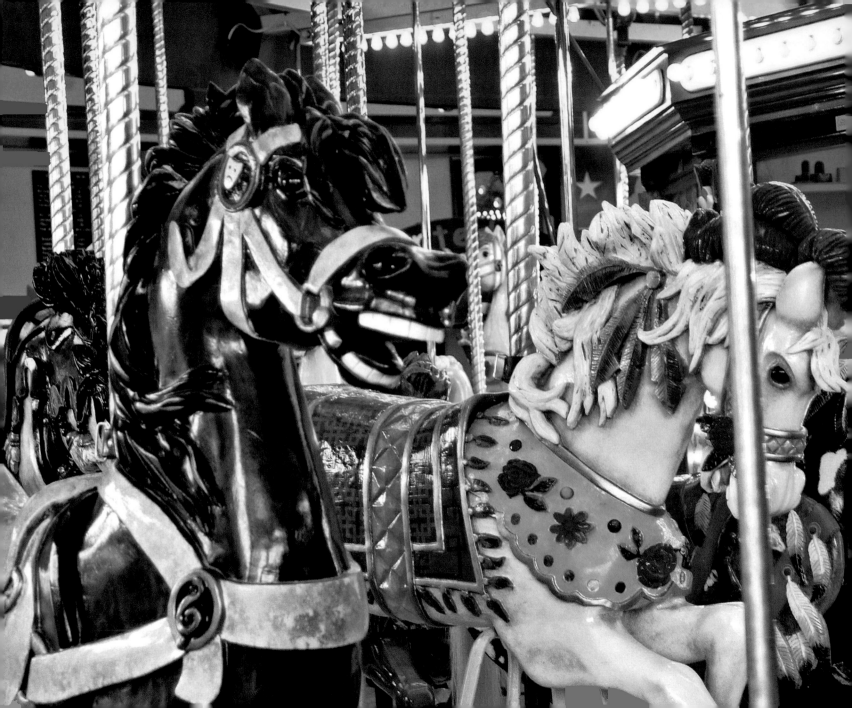

Left: The Missoula community joined together in the 1990s to build the nation's first completely hand-carved carousel in more than sixty years. The sounds of a hand-made wooden pipe organ accompany children reaching for the brass ring from the elaborate ponies. PHOTO BY DONNIE SEXTON / TRAVEL MONTANA

Below: Missoulians lock their cruiser bikes to this bicycle-shaped rack in Caras Park on their way to one of the many festivals held there throughout the year.

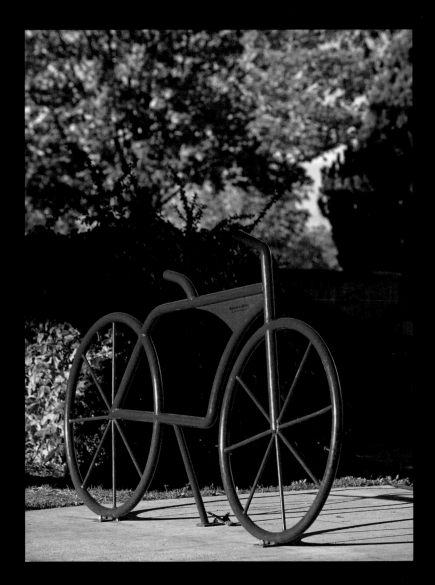

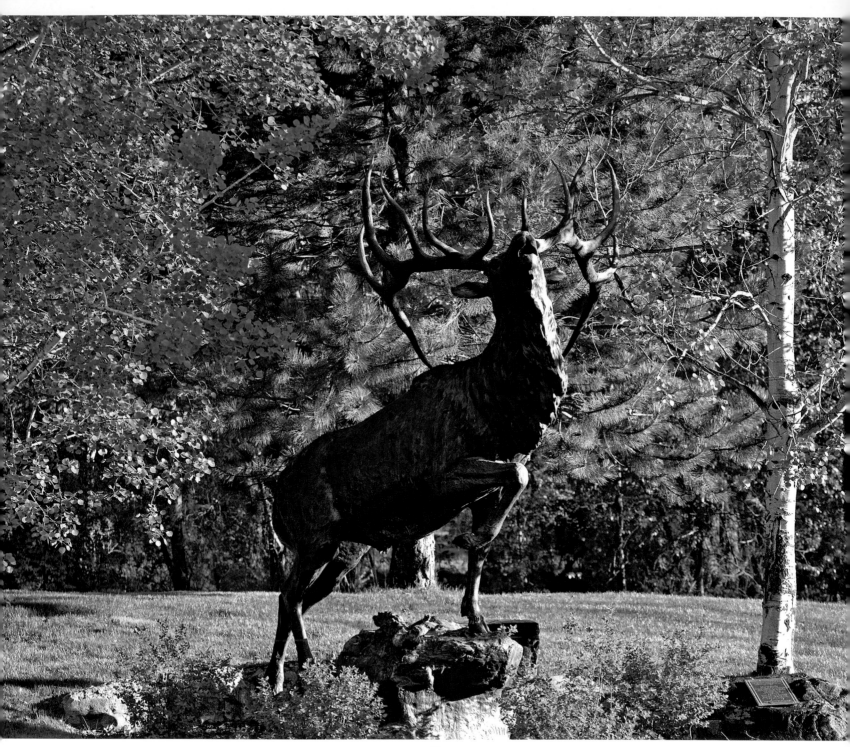

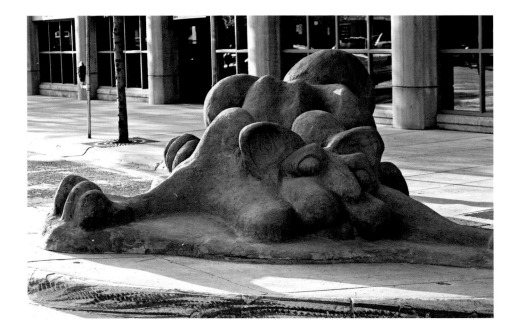

Left: Missoula's parking garage cat on Main Street is reminiscent of the city bus system, the Mountain Line.

Below: This bronze trout swims in Caras Park, on the riverfront.

Facing page: A bronze elk greets visitors to the Rocky Mountain Elk Foundation visitor center. Elk antlers, bugles, and tracks are on display, inviting you to learn more about elk and ongoing conservation of their habitat.

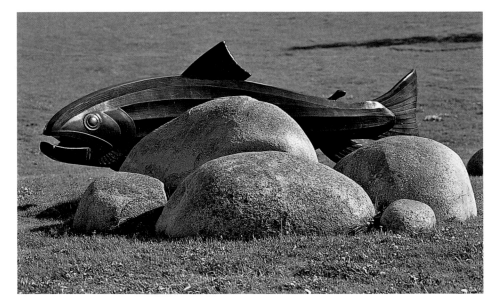

Right: The lower footbridge of Greenough Park straddles Rattlesnake Creek, dedicated by the Greenough family as a "comfortable, romantic, and poetic retreat" in the lower Rattlesnake neighborhood. On the Arnold Bolle interpretive birding trail, dippers, buntings, warblers, woodpeckers, flickers, and the western screech-owl peek out from the tree cover.

Far right: Early autumn snow falls in the two-million-acre Lolo National Forest, which harbors 1,000 named streams, the Montana champion ponderosa pine, and the national co-champion western larch.

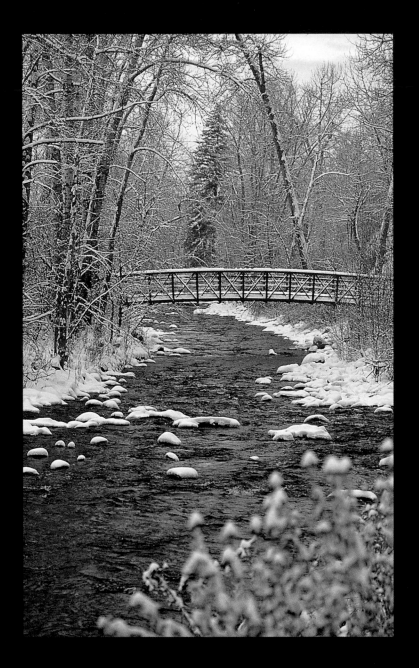

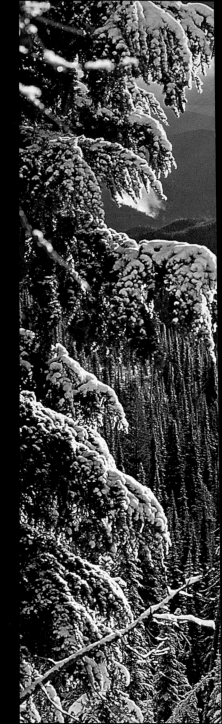

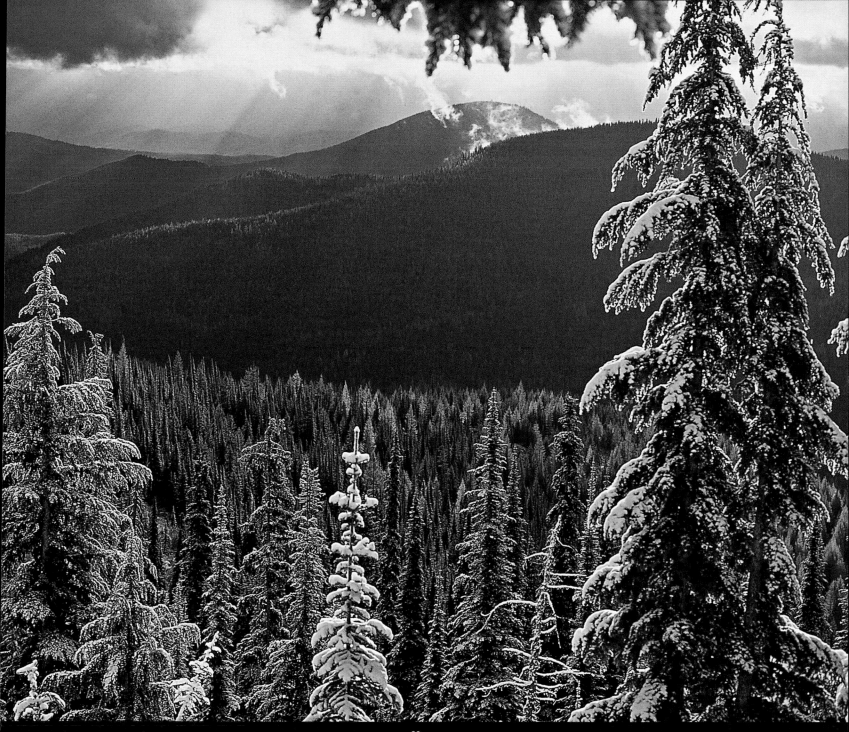

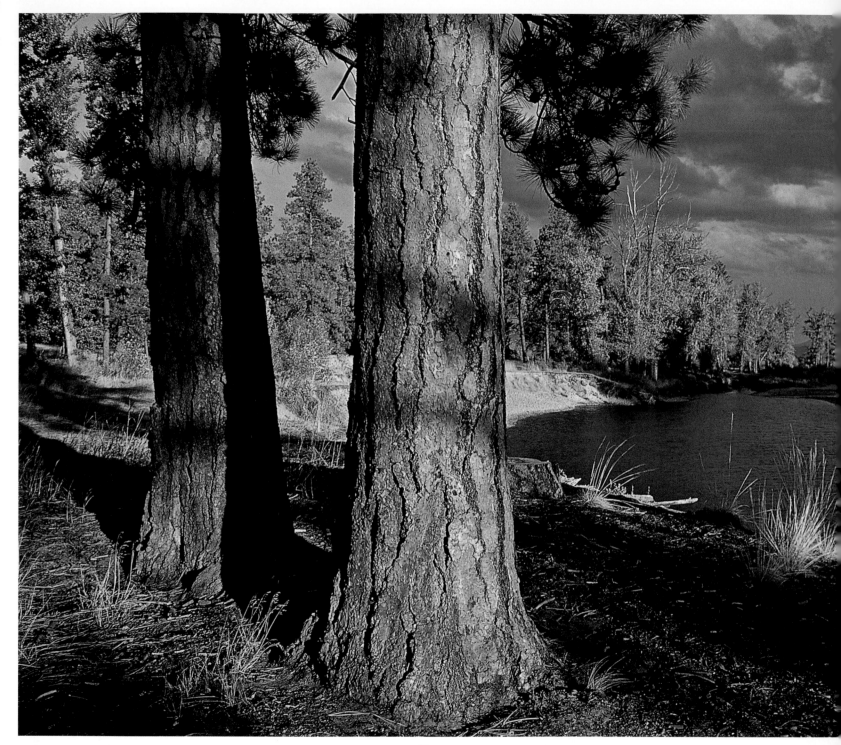

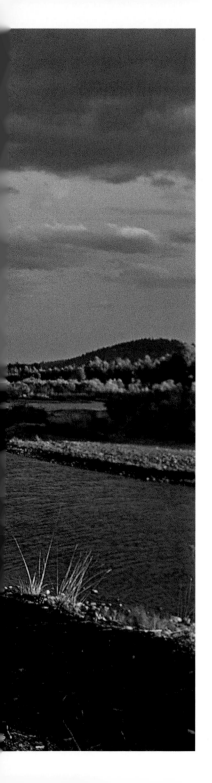

Left: The Clark Fork River meanders past Council Grove, the site among majestic pines where the U.S. government and the Salish, Kootenai, and Pend d'Orielle Indians negotiated the Hellgate Treaty in 1855, creating the Flathead Indian Reservation.

Below: Missoula is well known for its weather inversions—thus the beautiful, colorful, foggy sunrise.

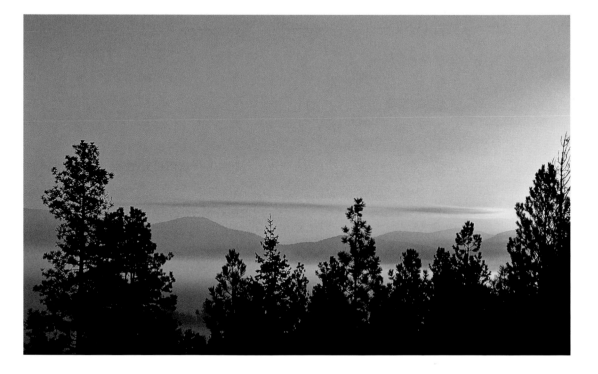

Right: Fox pups are curious neighbors.

Facing page: A white-tailed doe emerges at the urban-wildland interface in Missoula's South Hills neighborhood. Missoula's many homes built in proximity to wildlands create mounting challenges for wildlife and fire management.

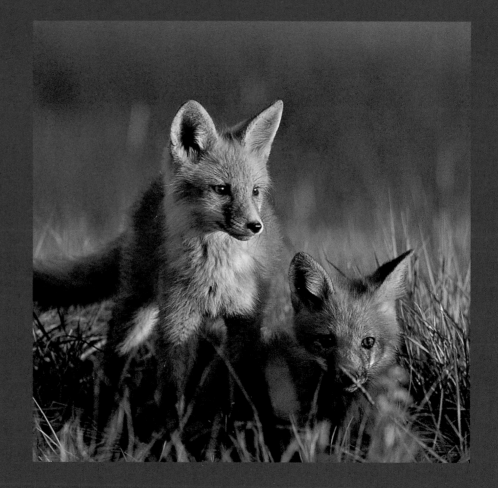

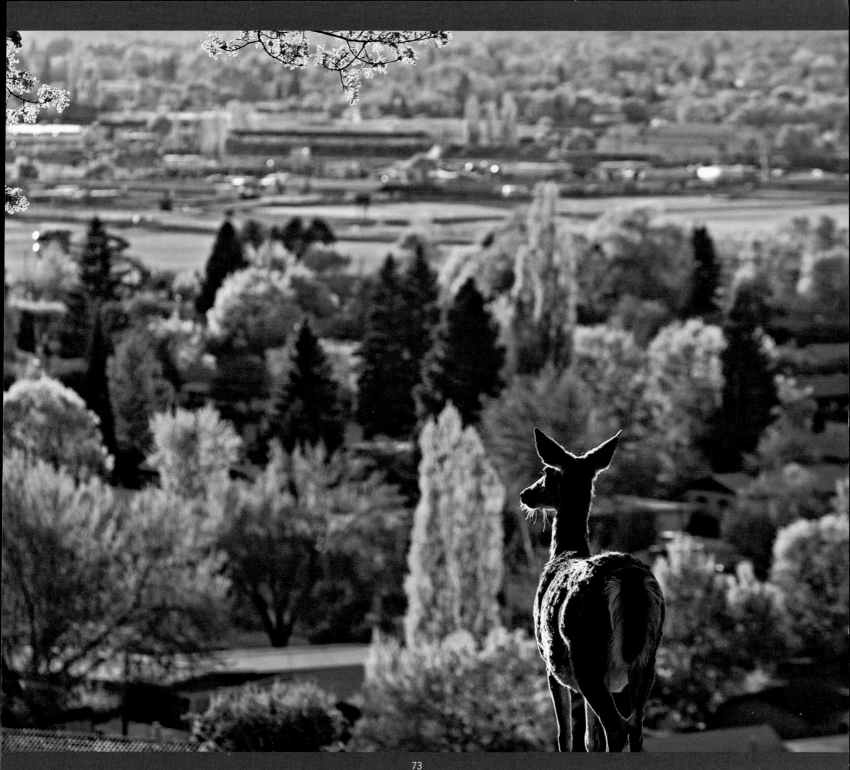

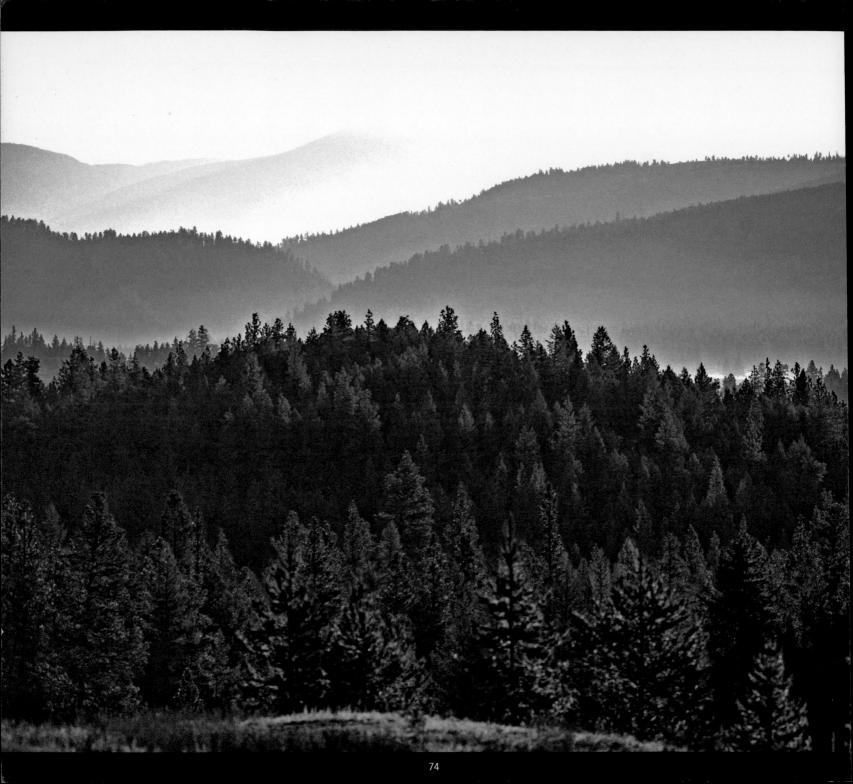

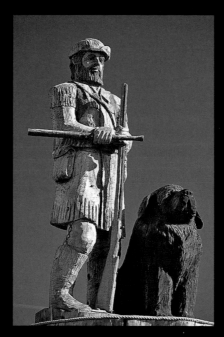

Left: Meriwether Lewis's beloved Newfoundland dog, Seaman, accompanied the Corps of Discovery and is remembered here in a chainsaw carving in Bonner.

Far left: In the Garnet Mountains east of Potomac, gold miners once lived in the towns Beartown, Top O'Deep, and Reynolds City, all now only legends.

Below: The Lewis and Clark Expedition camped at the edge of Packer Meadows on Lolo Pass in 1805. For centuries before Lewis and Clark arrived, the Nez Perce traversed the nearby Lolo Trail across the Bitterroot Mountains en route from Idaho to bison hunting grounds on Montana's eastern plains.

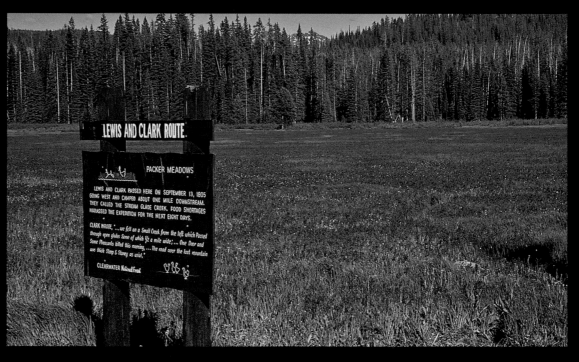

Top right: Pasque flowers bloom on Blue Mountain, surrounded by a 5,500-acre recreation area just two miles southwest of Missoula.

Bottom right: Wild huckleberries, a close relative of blueberries, are a Montana favorite.

Facing Page: Wild camas at Packer Meadows are still harvested by the Nez Perce Indians.

Below: Broad fields of the delicate bitterroot once covered the Missoula Valley. Native Americans harvested the roots for food and trade.

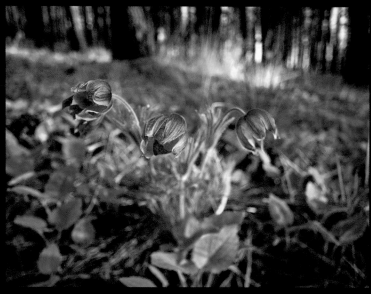

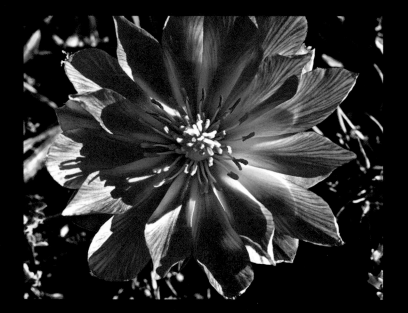

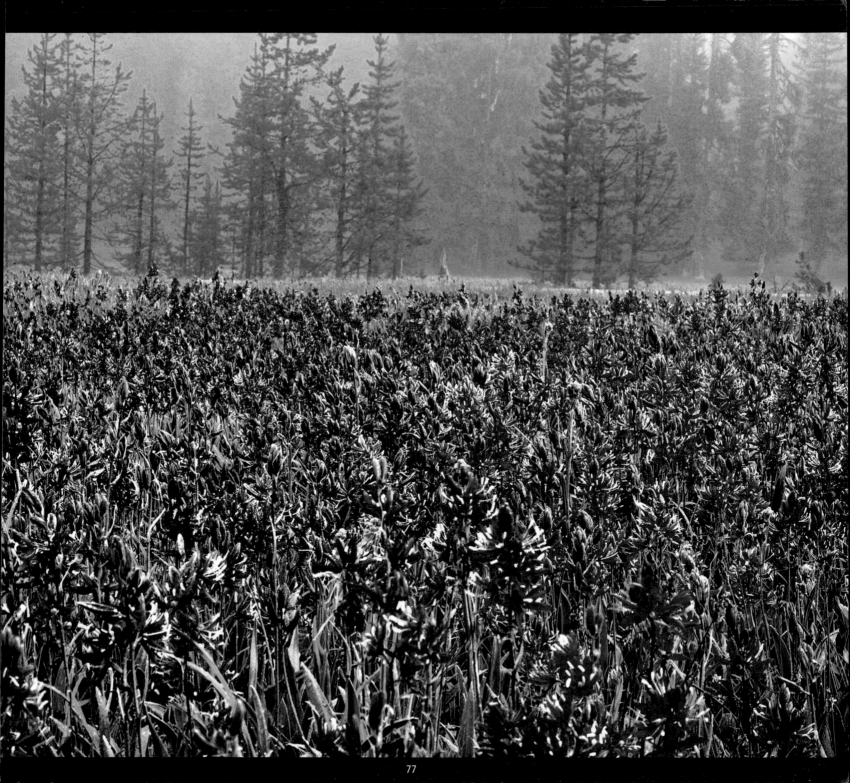

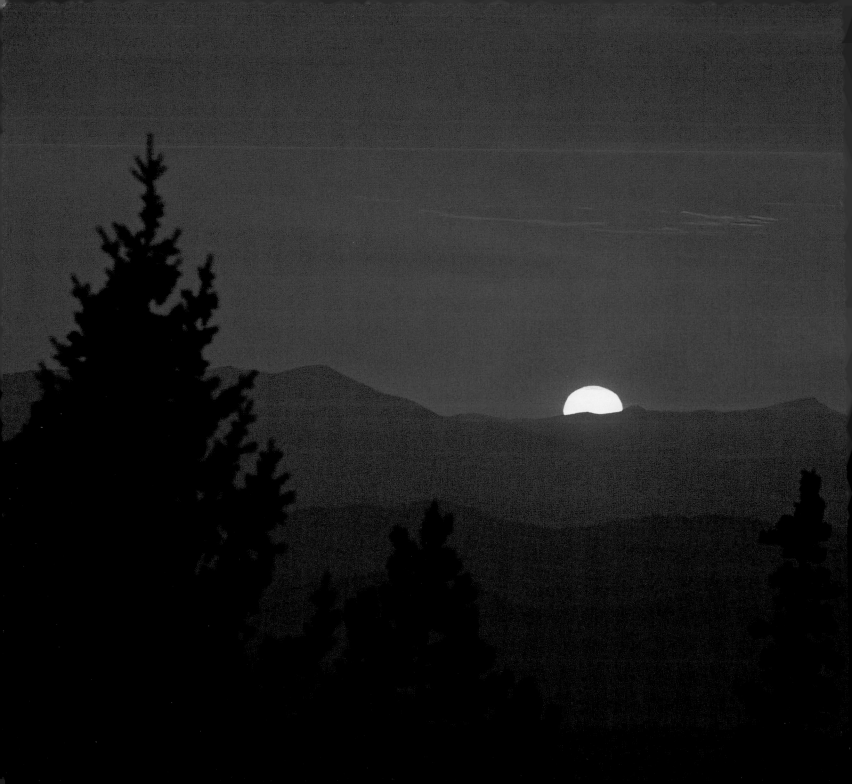

Left: The historic Union Peak Fire Lookout provides an unparalleled view of sunset in the Garnet Range.

Below: The rising sun profiles a majestic bull elk at the National Bison Range.

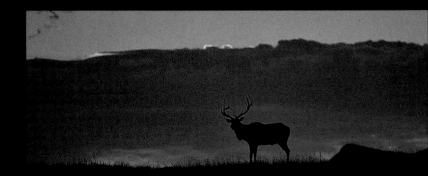

NELSON KENTER's interest in photography began decades ago, while taking black-and-white Polaroid snapshots on family vacations. Growing up in northern Wisconsin helped spawn a love for the outdoors. His appreciation for the outdoors and a growing passion for photography and art led him to pursue a degree in commercial art.

In 1981 he moved to Missoula, Montana, and found his niche in the professional photography world. An avid outdoor enthusiast, he spends much of his time shooting stock photography of outdoor recreation, landscapes, and wildlife, as well as local Missoula landmarks, architecture, and cultural events. Over the years, Nelson has carried his camera gear with him while hiking up mountains, paddling down rivers, and backpacking through remote wilderness areas.

Matching his passion for Montana with a talent for aesthetic presentation, Nelson captures many of the highlights of the Five Valleys area in this varied collection of images. Please enjoy more of his photographs at: www.kenterphotography.com